PRAIRIE VISIONS PHOTOGRPHY

Featuring David Clark

Color nude male physique photography

Photographed in the
Sandhills of Western Nebraska

©2009 Prairie Visions Photography
Lincoln, Nebraska

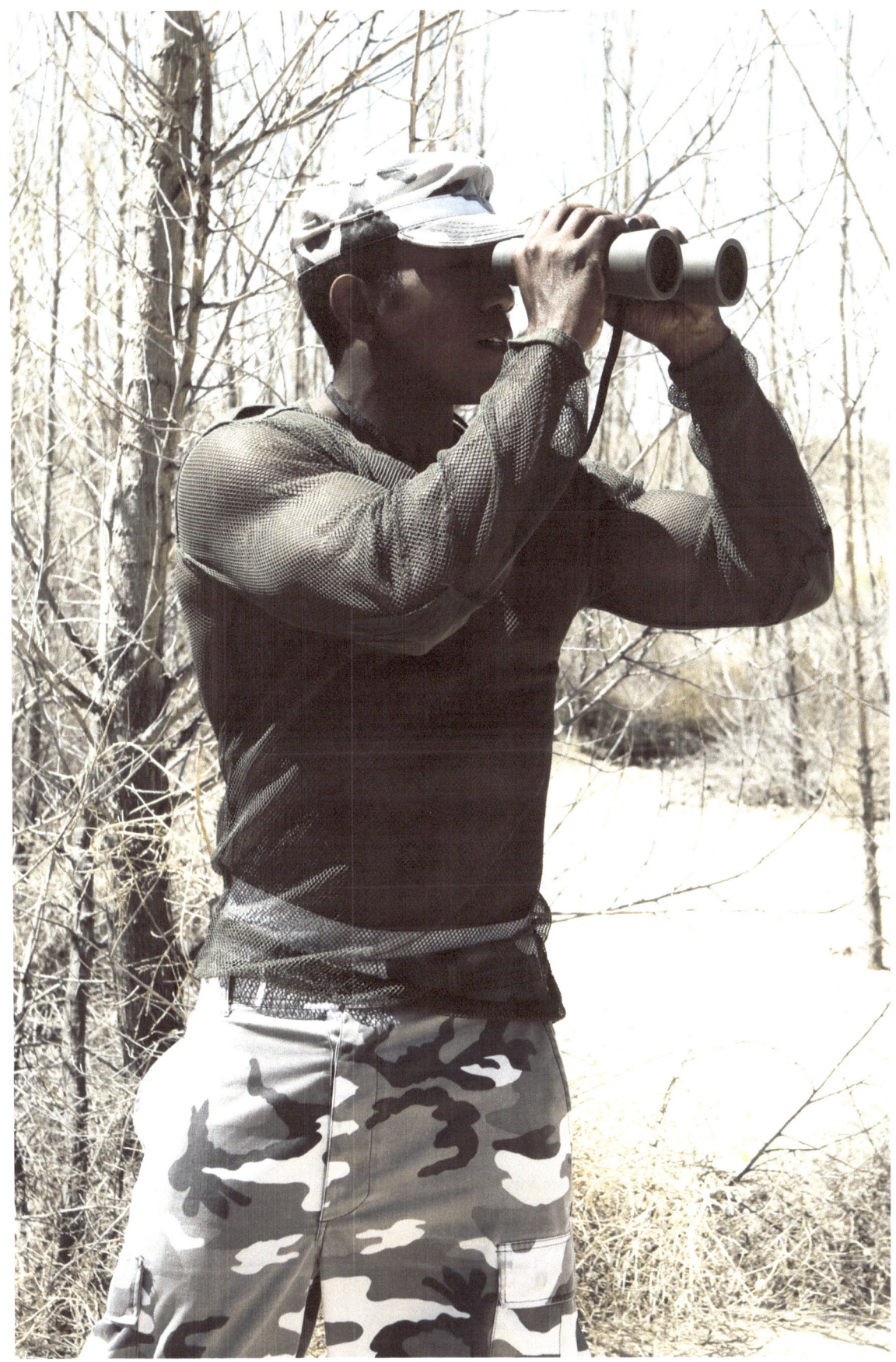

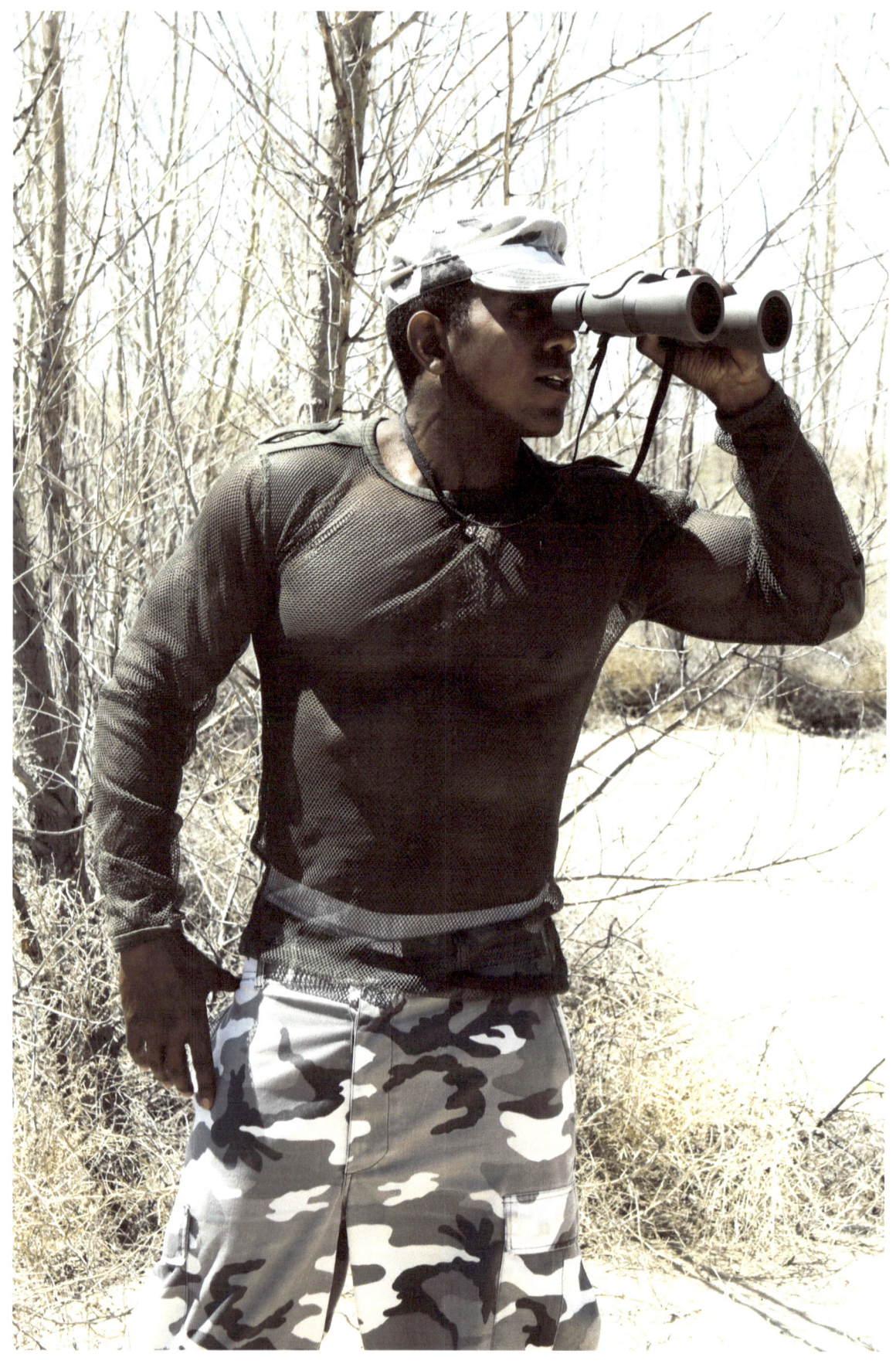

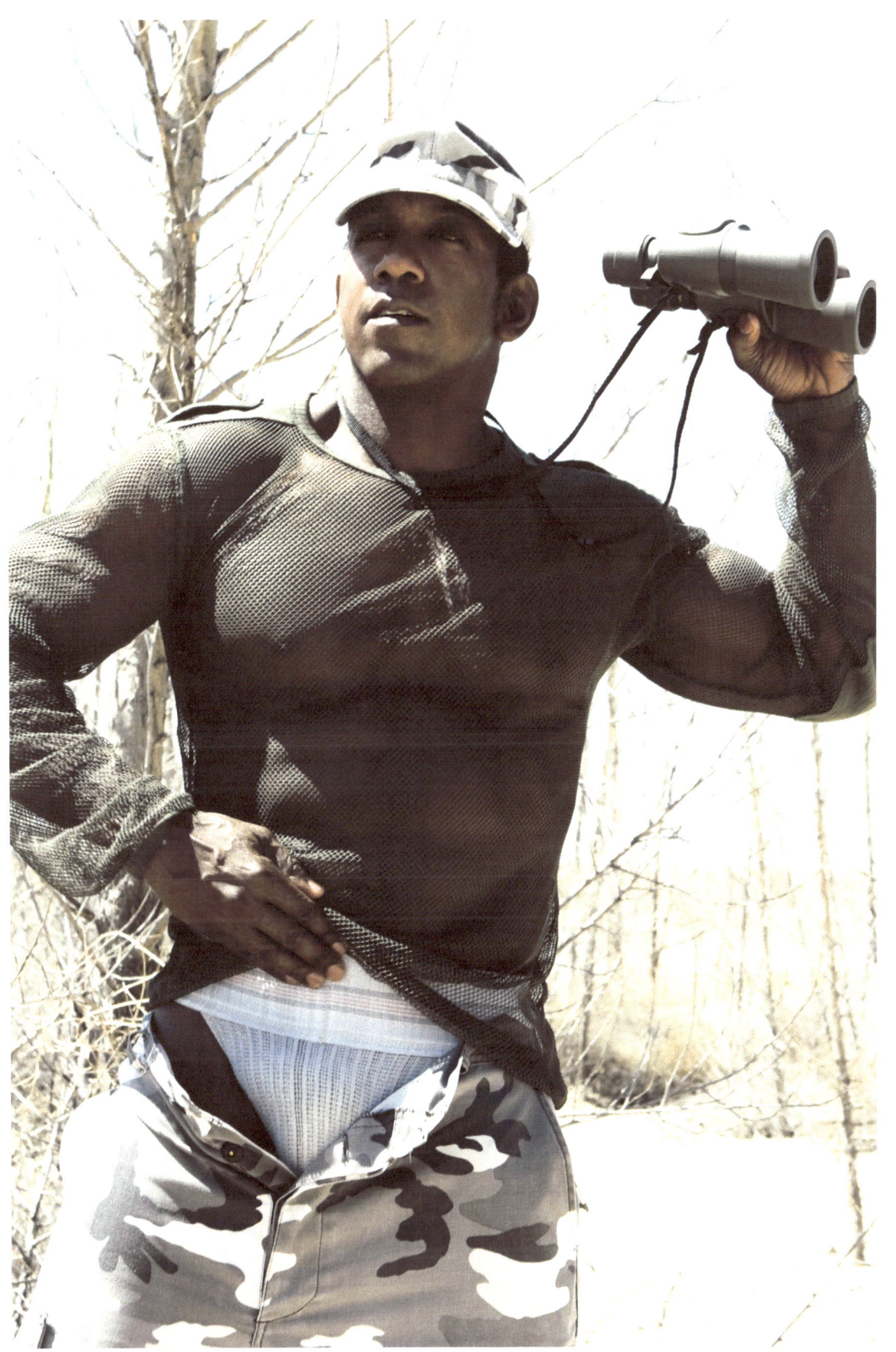

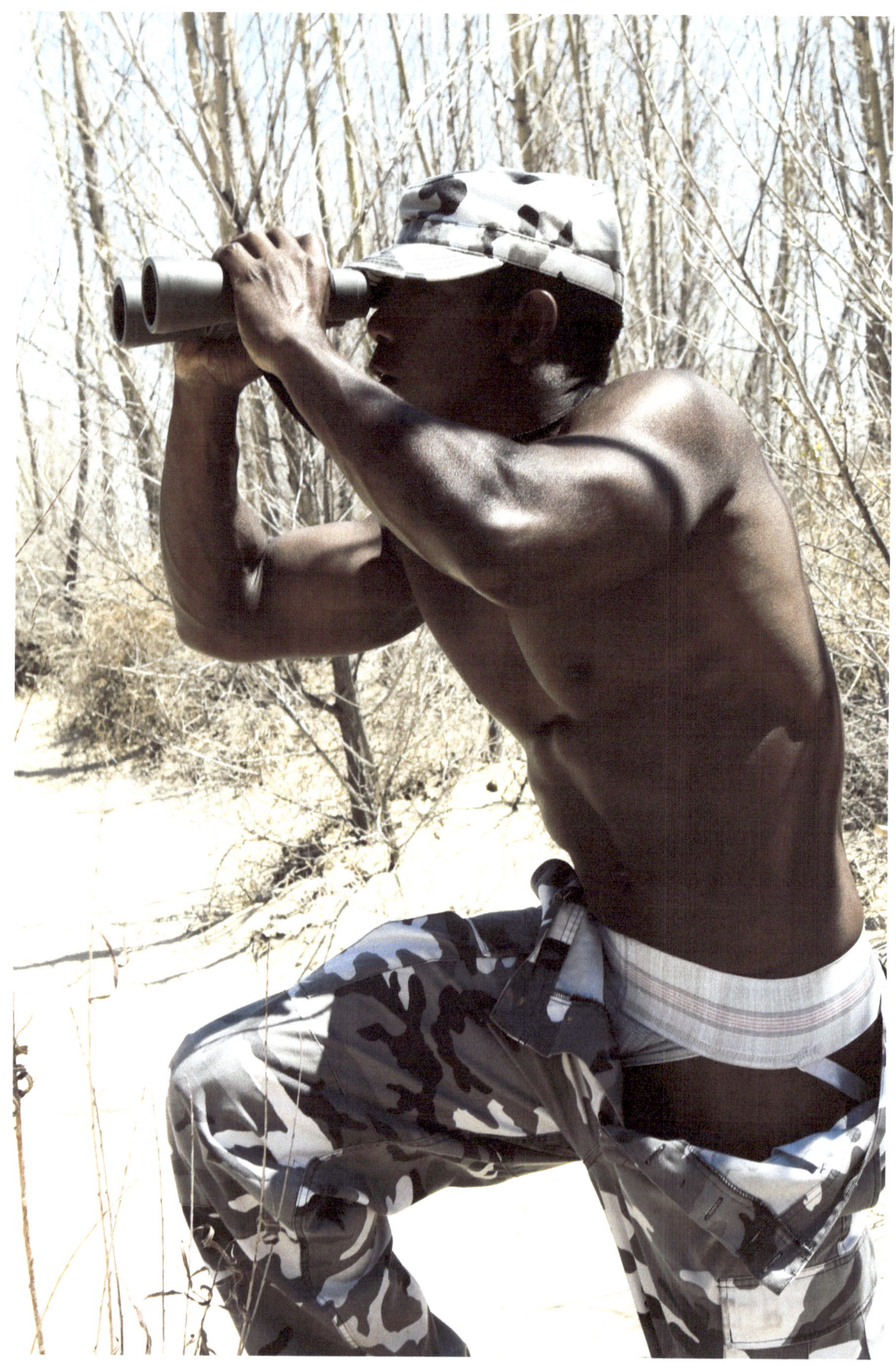

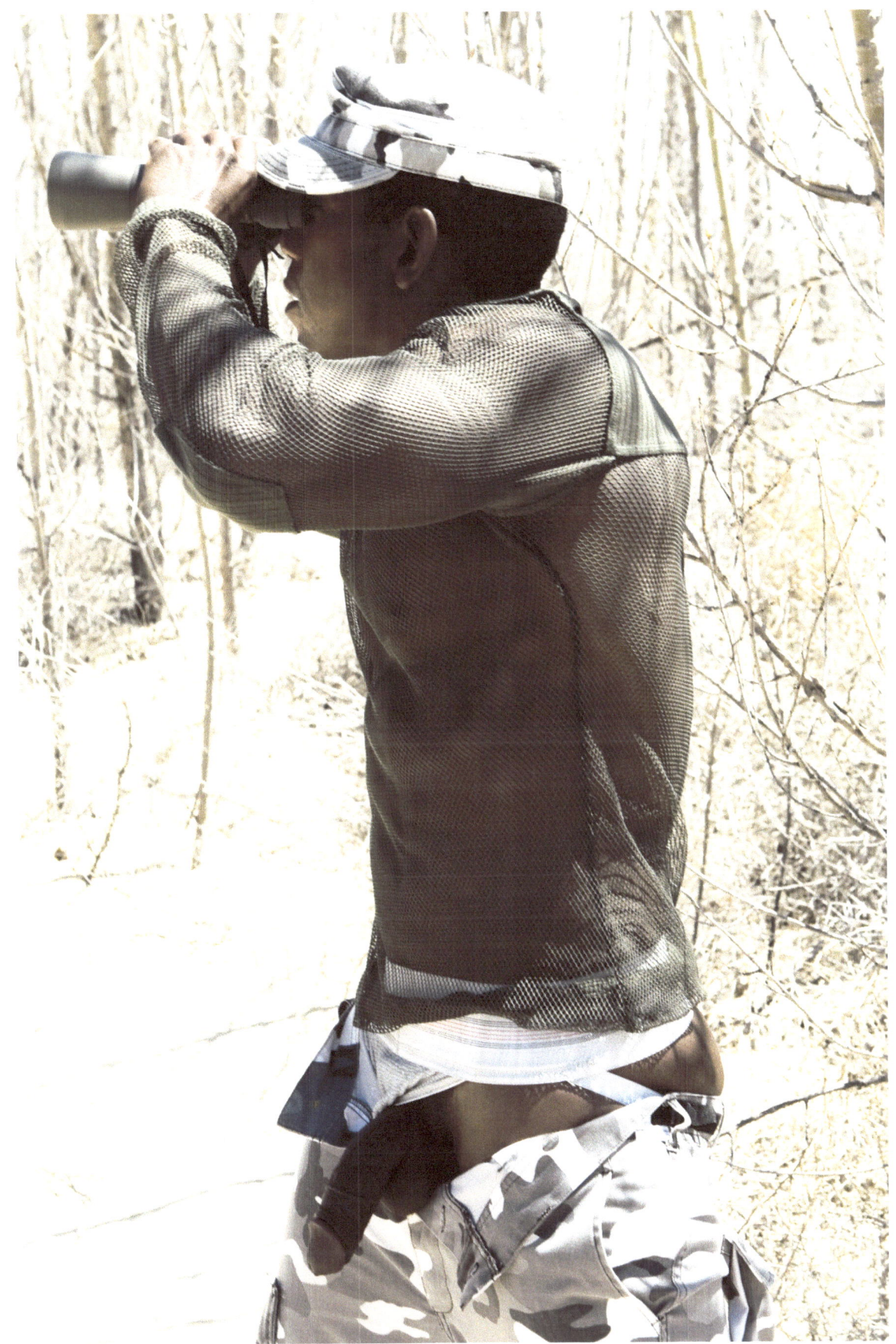

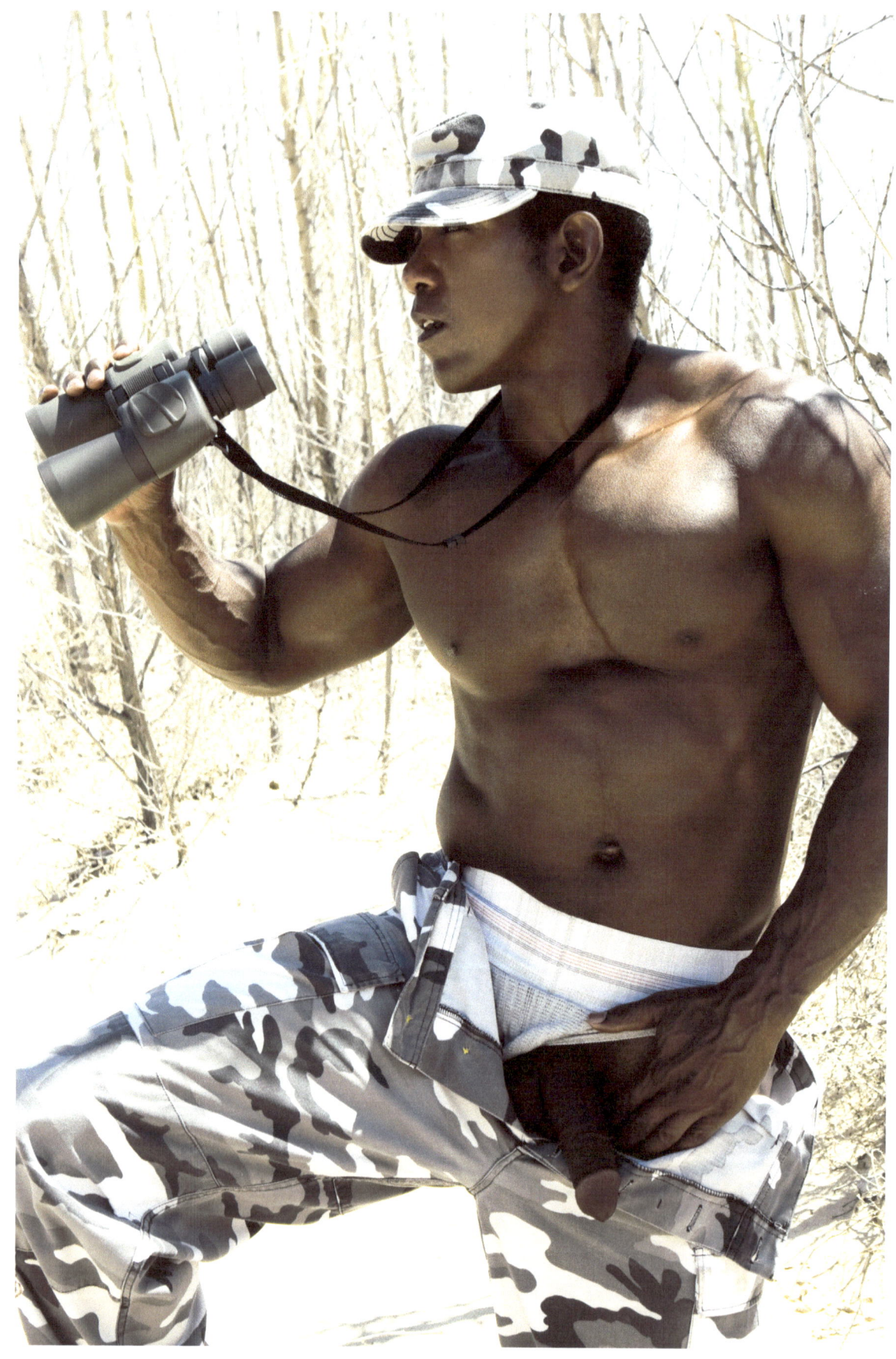

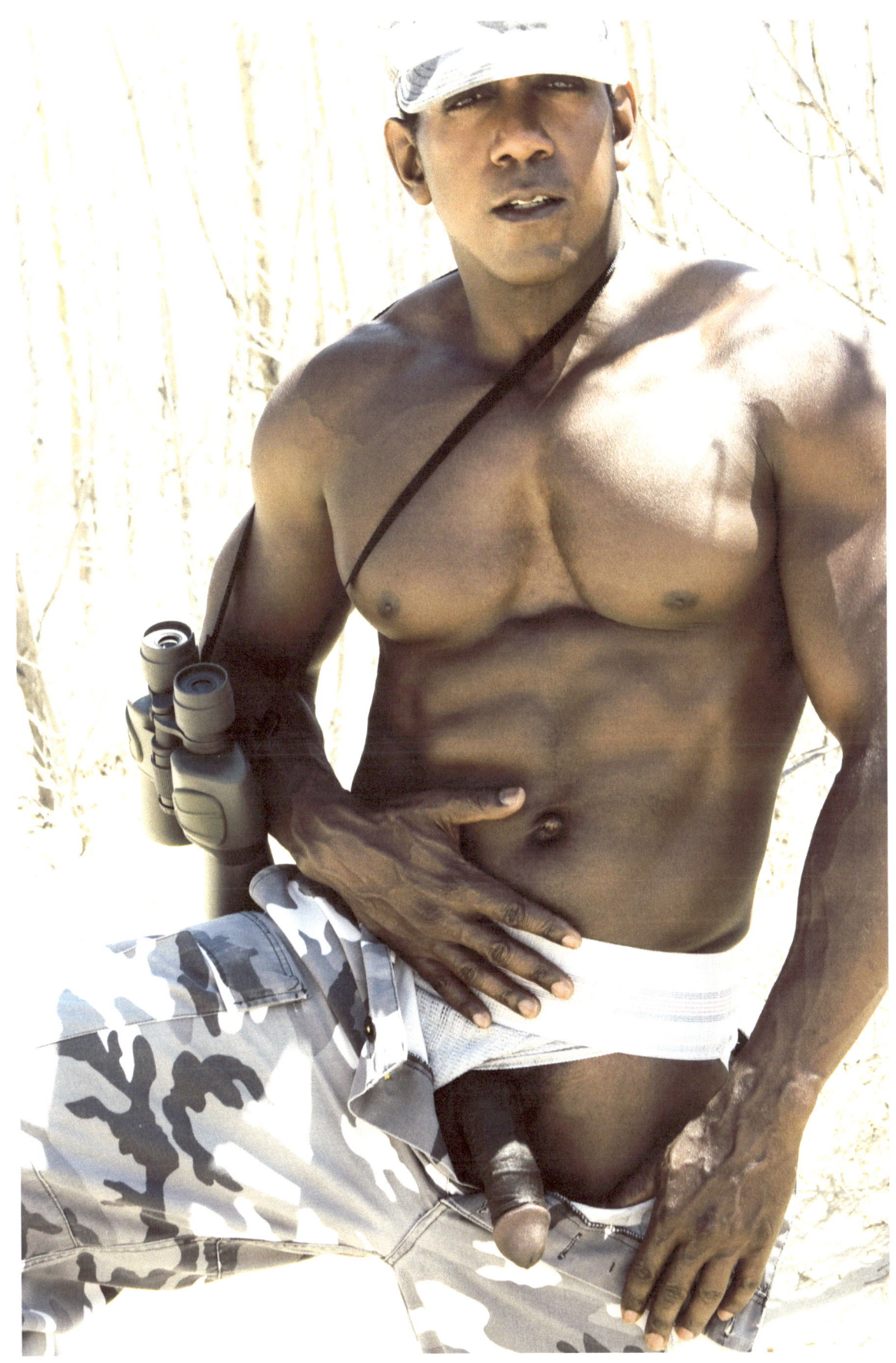

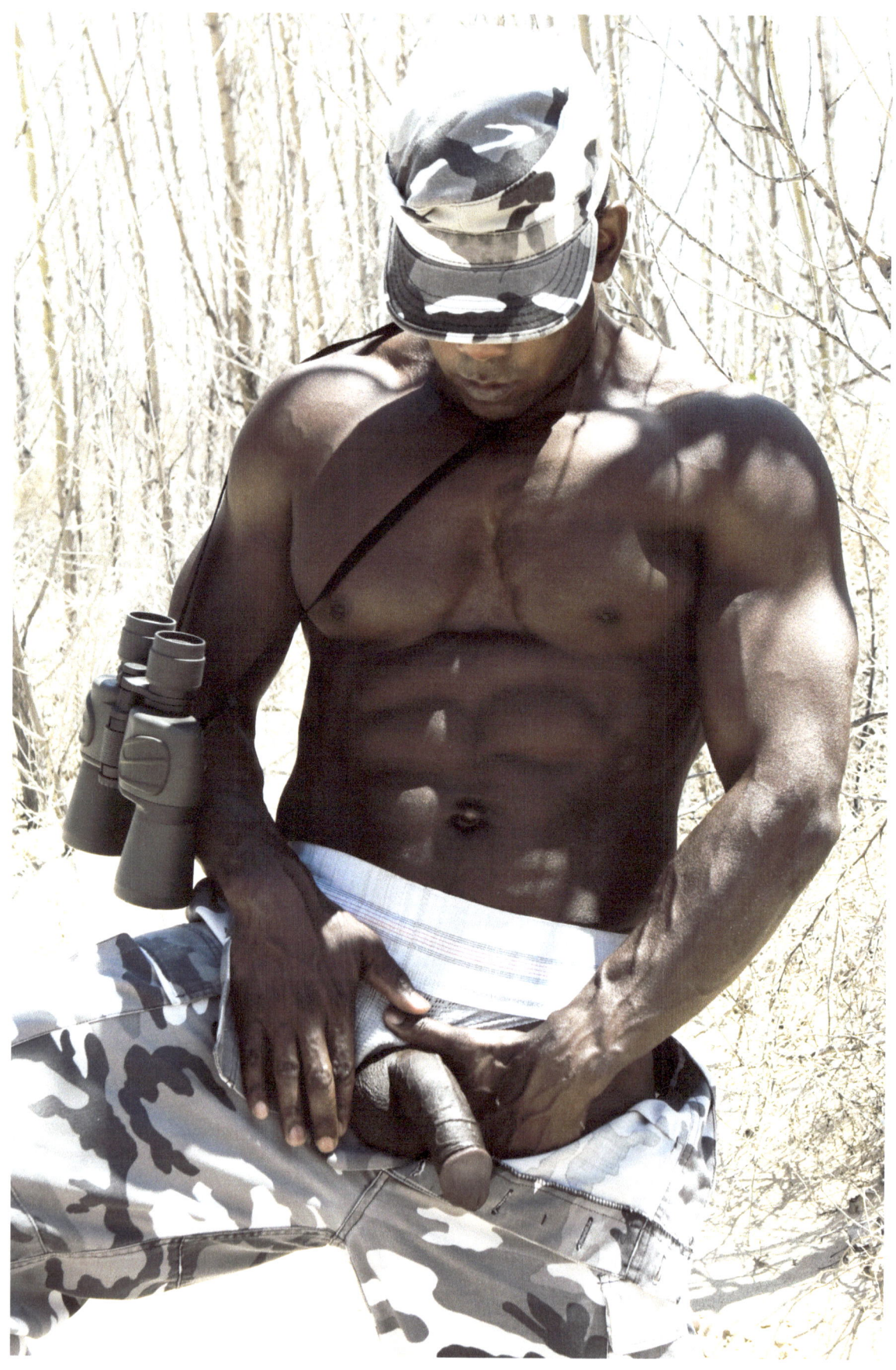

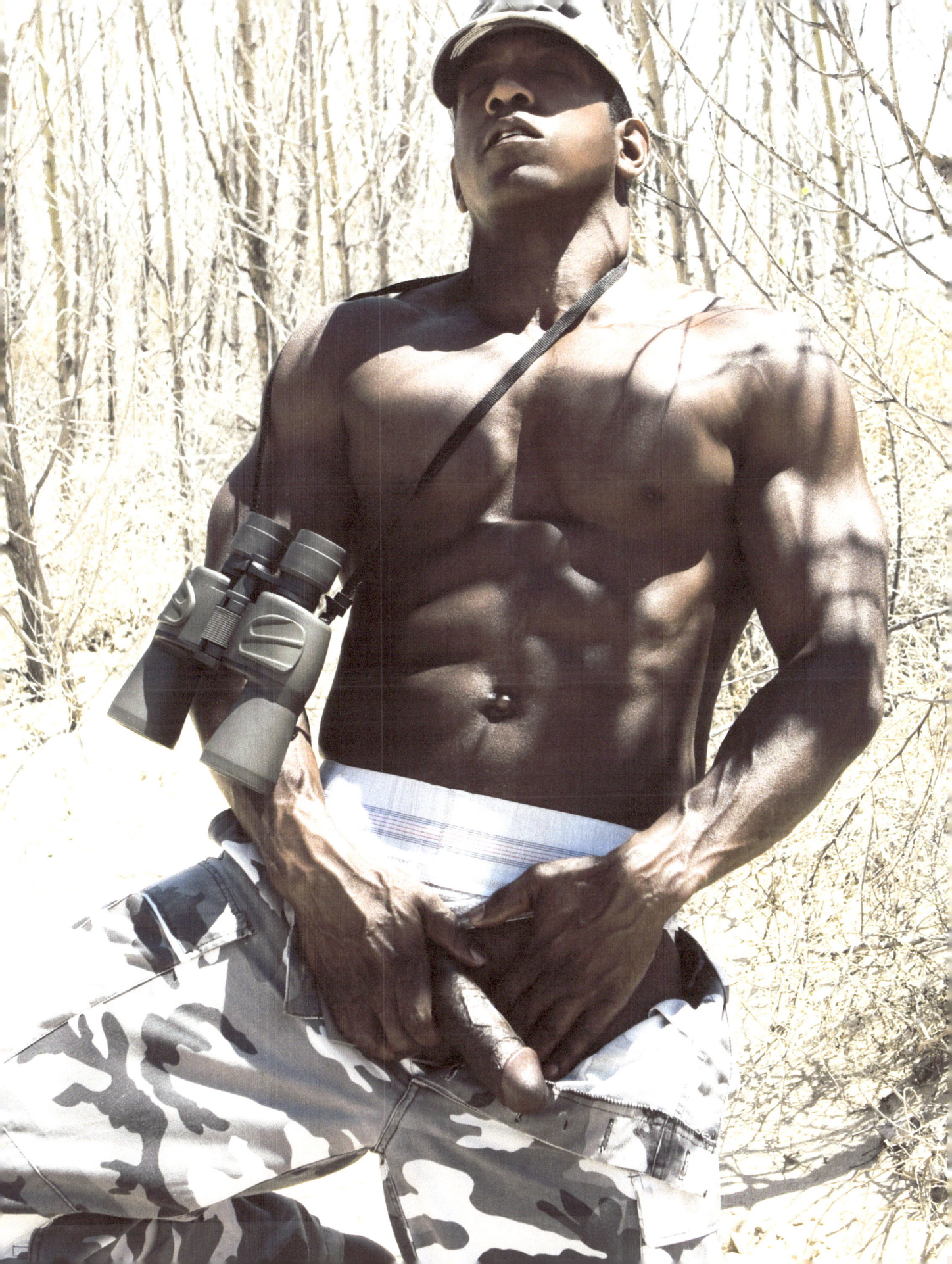

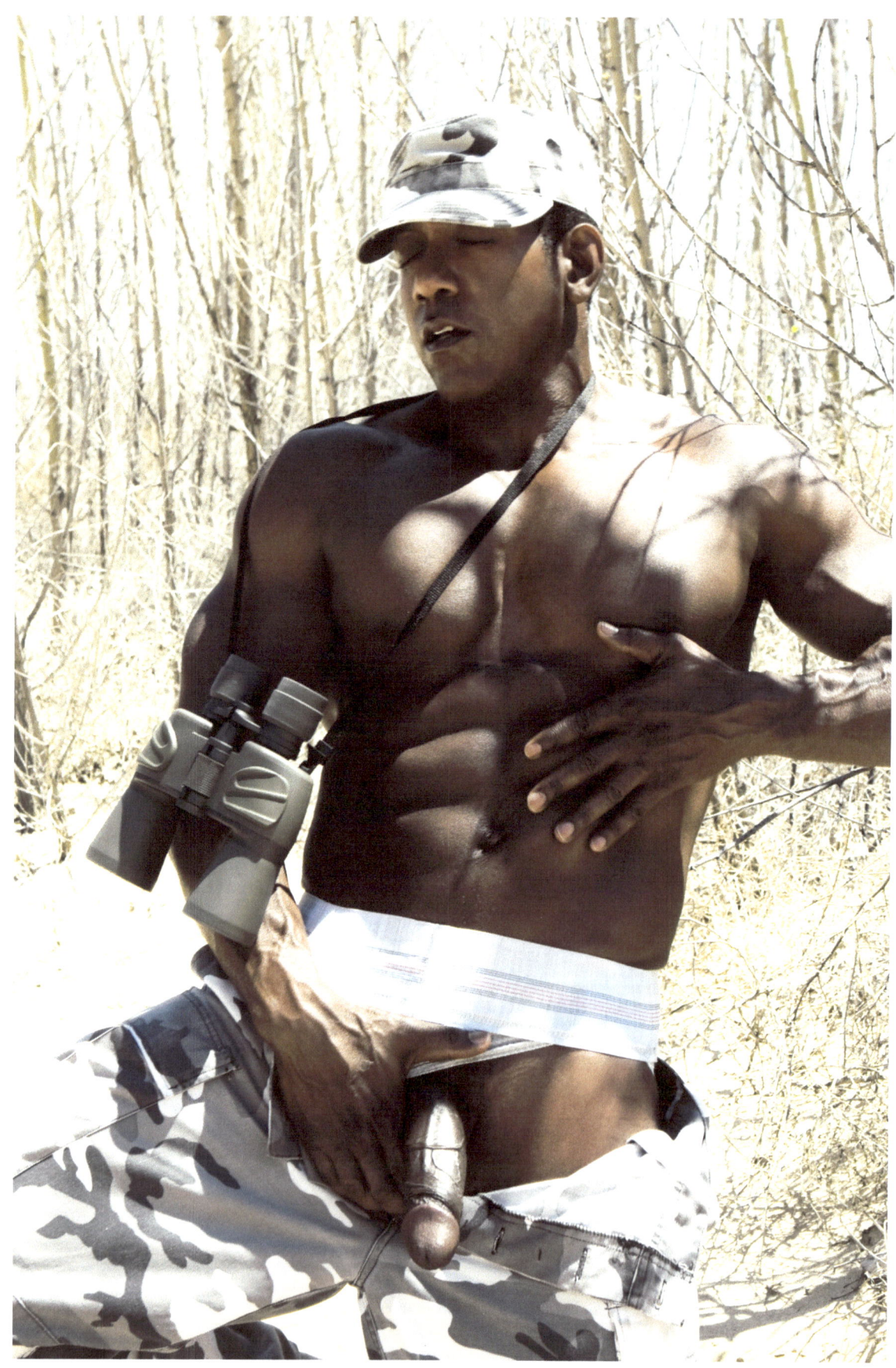

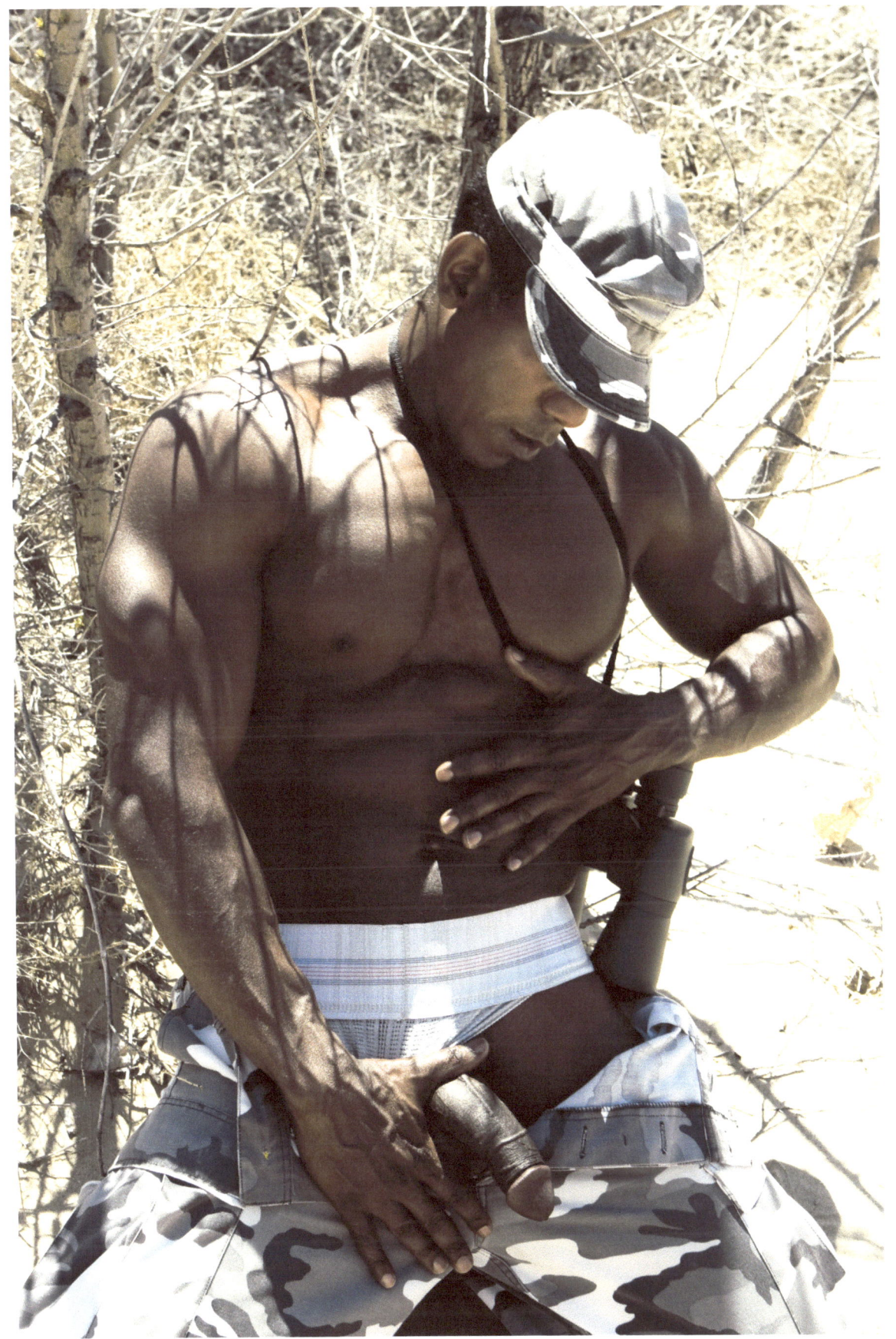

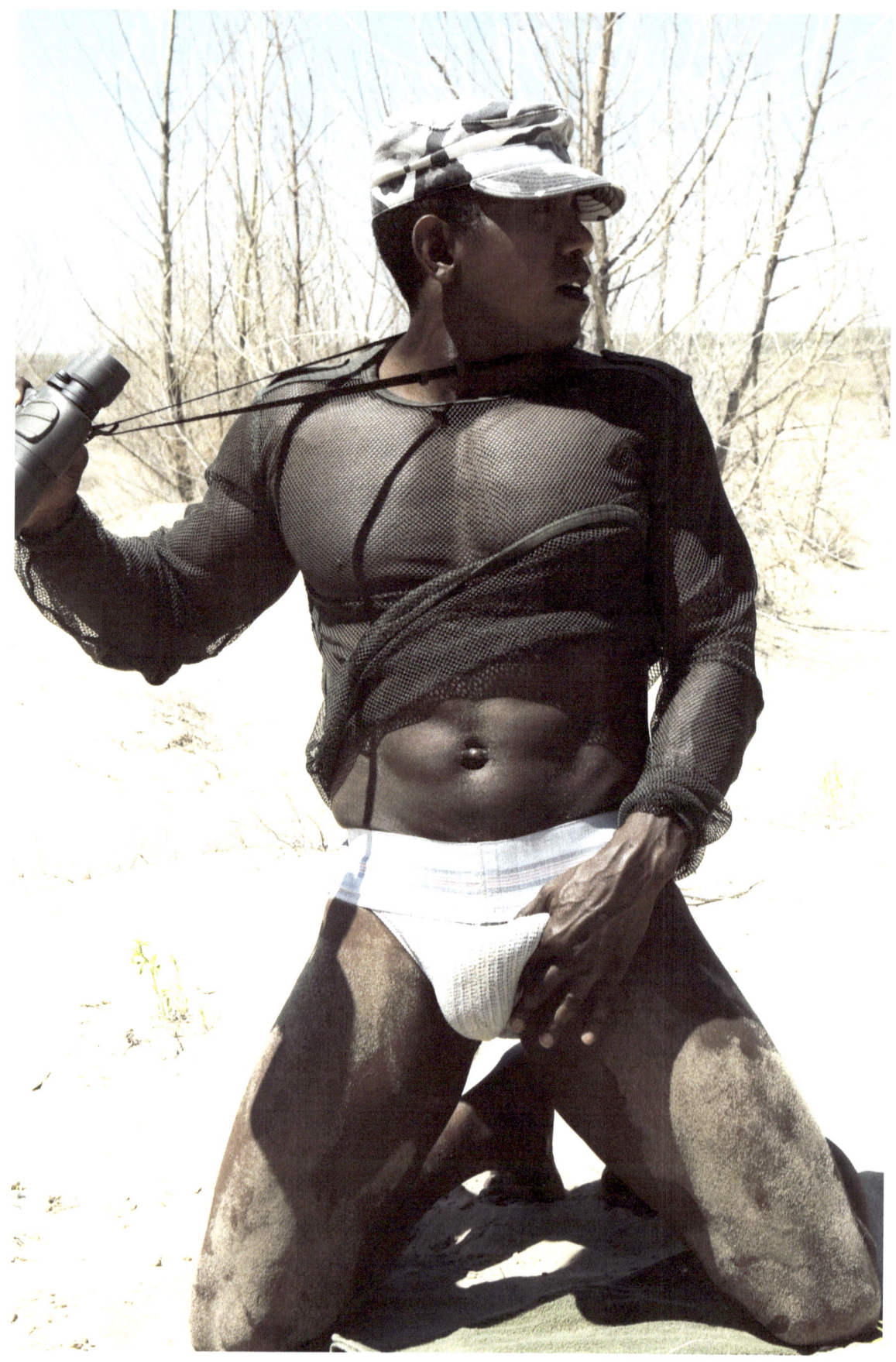

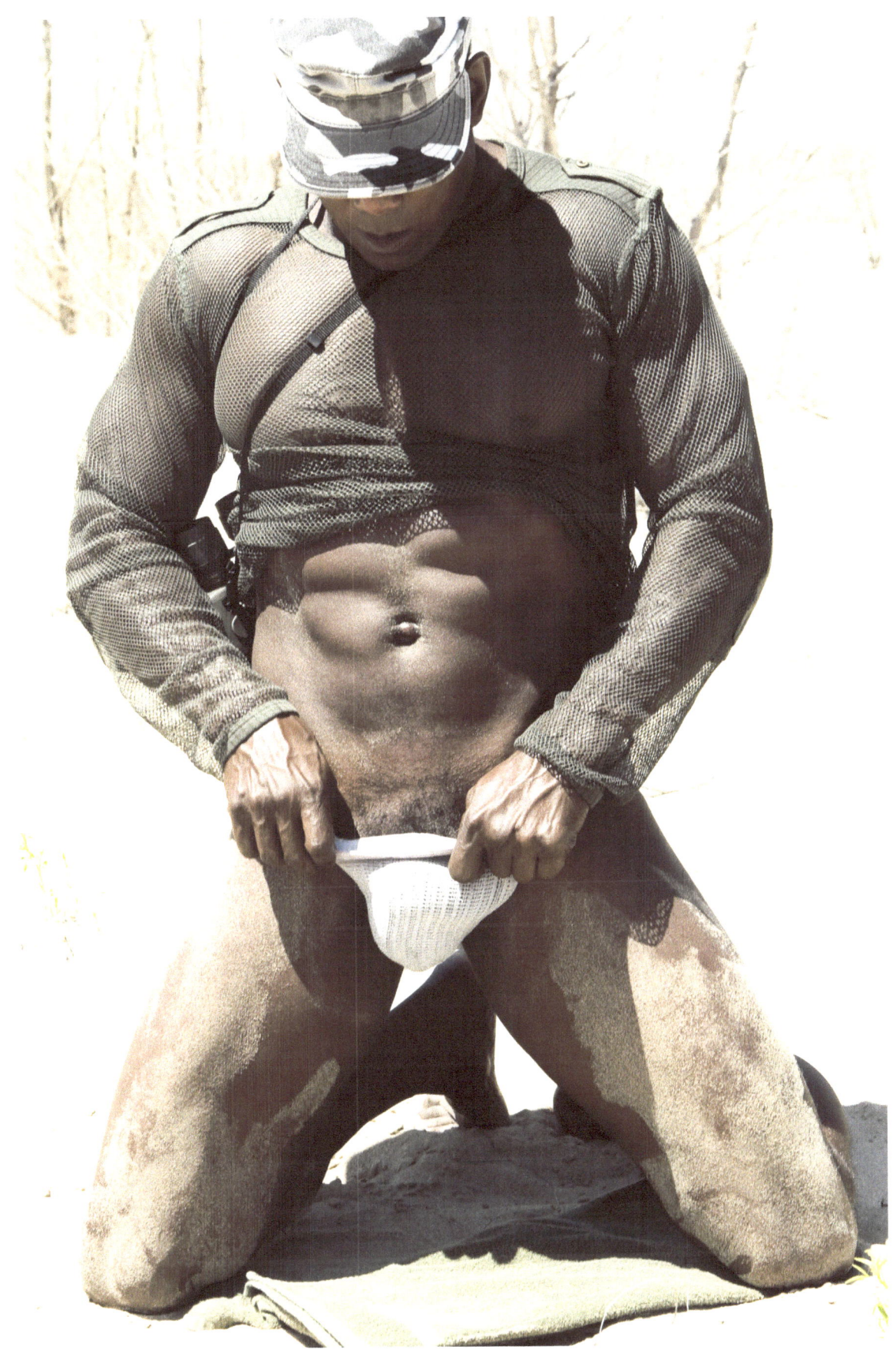

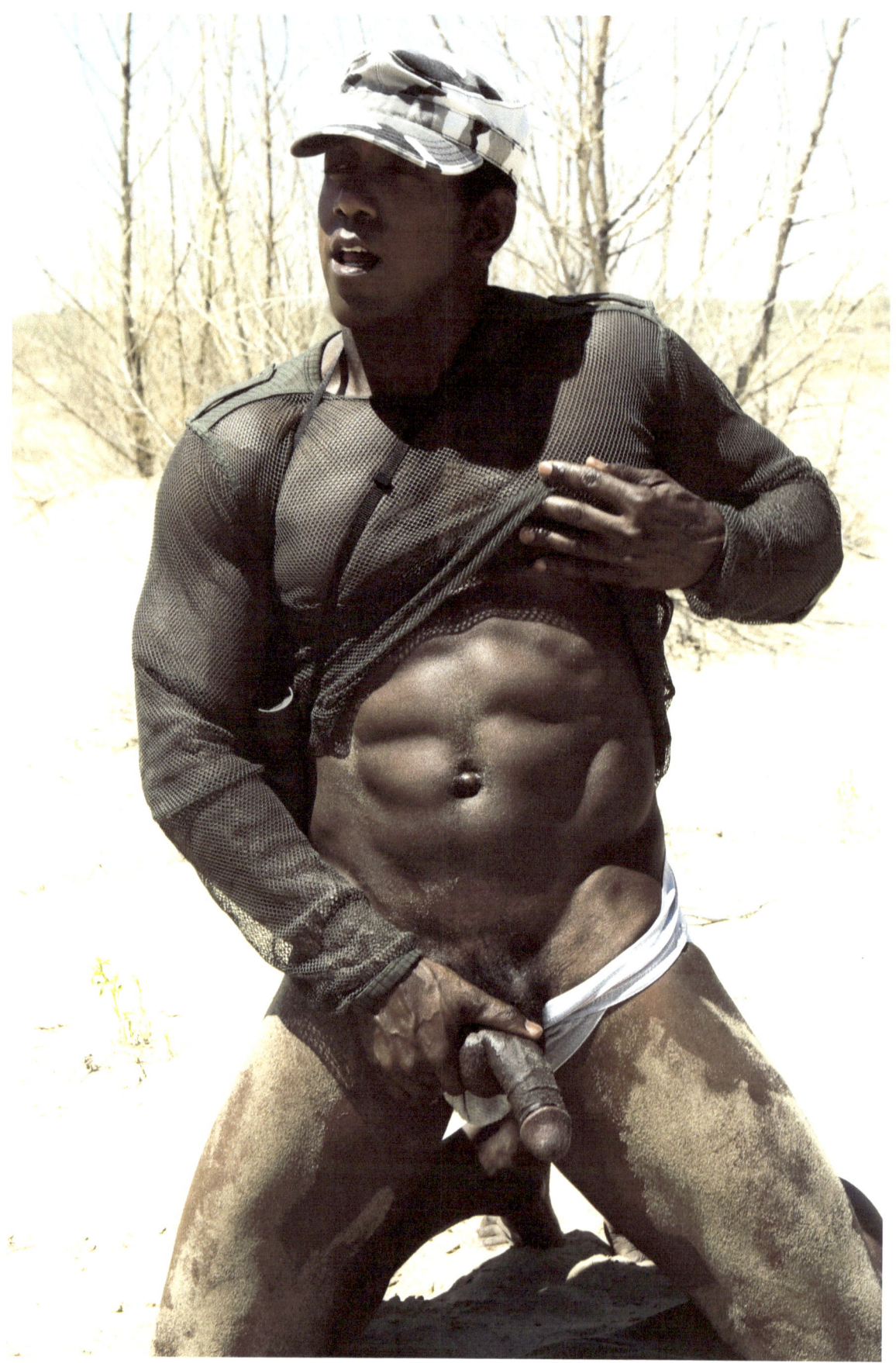

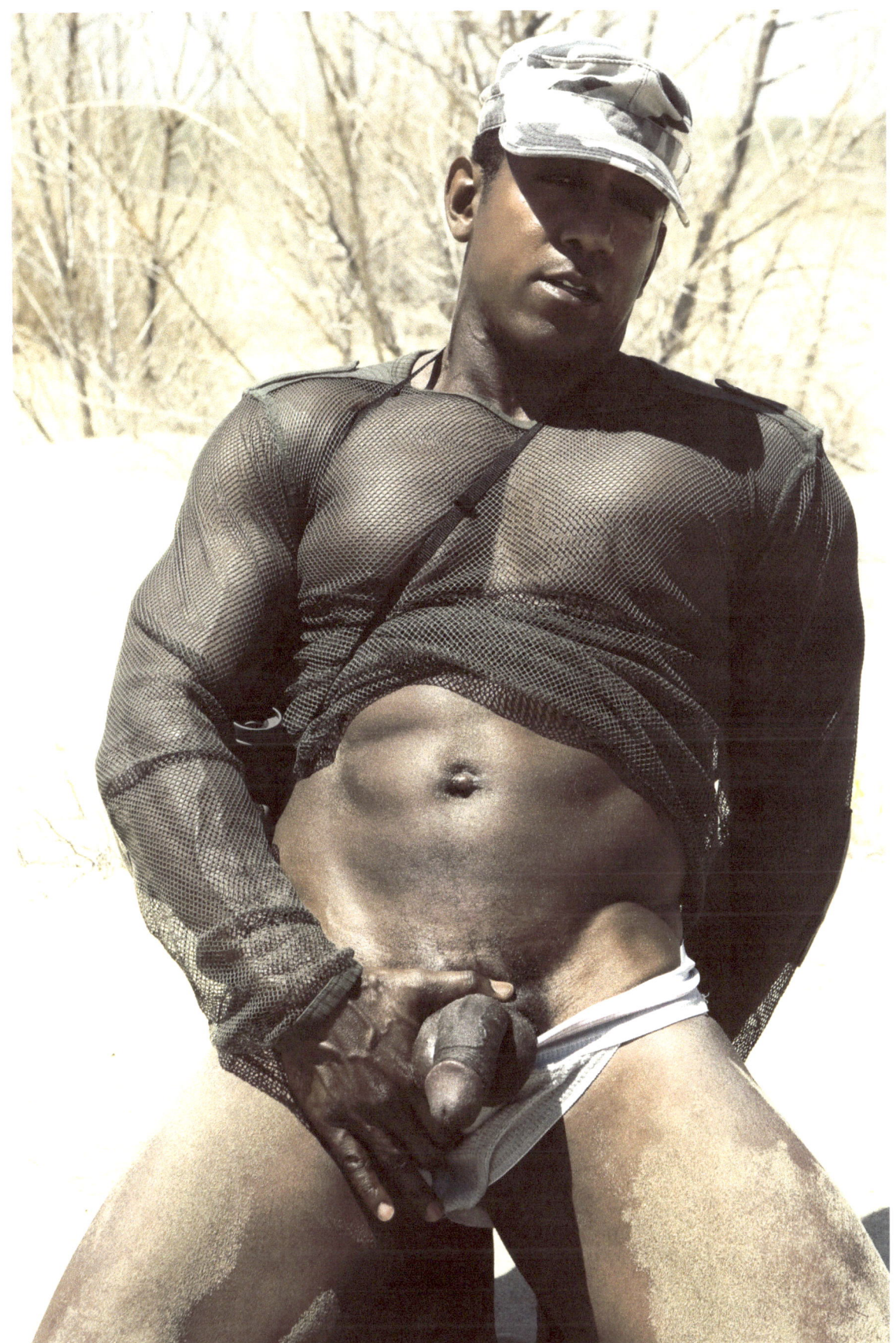

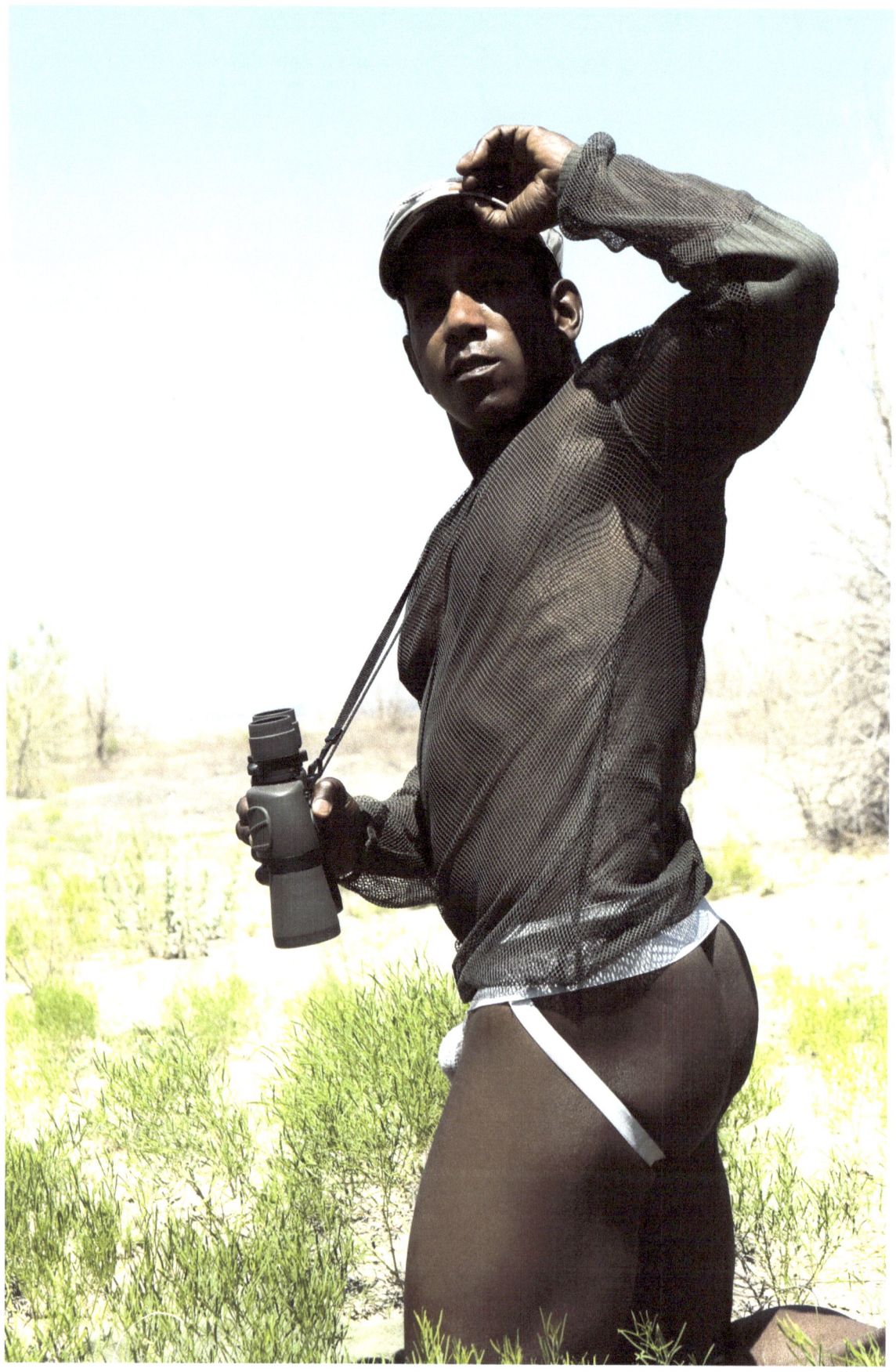

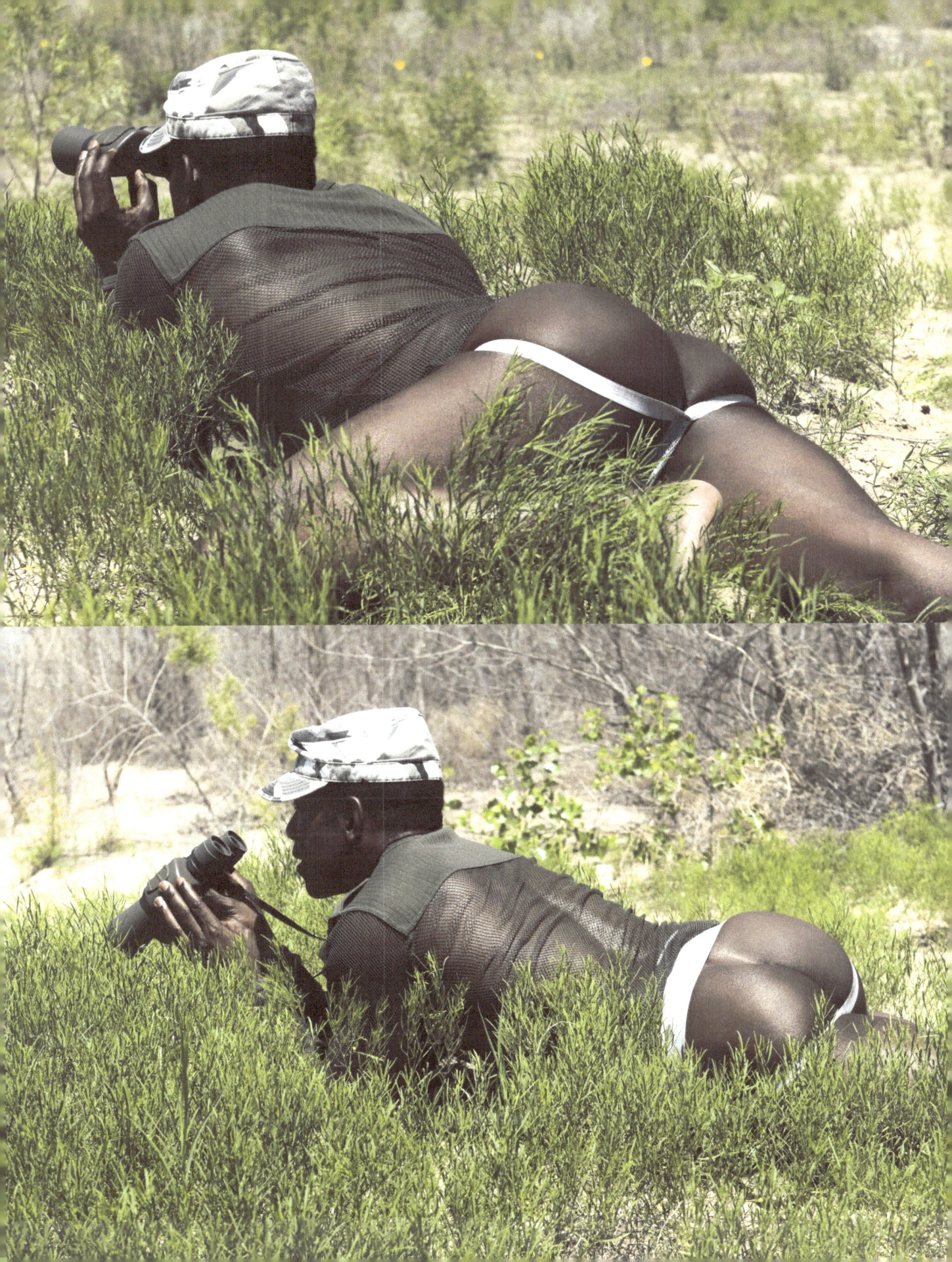

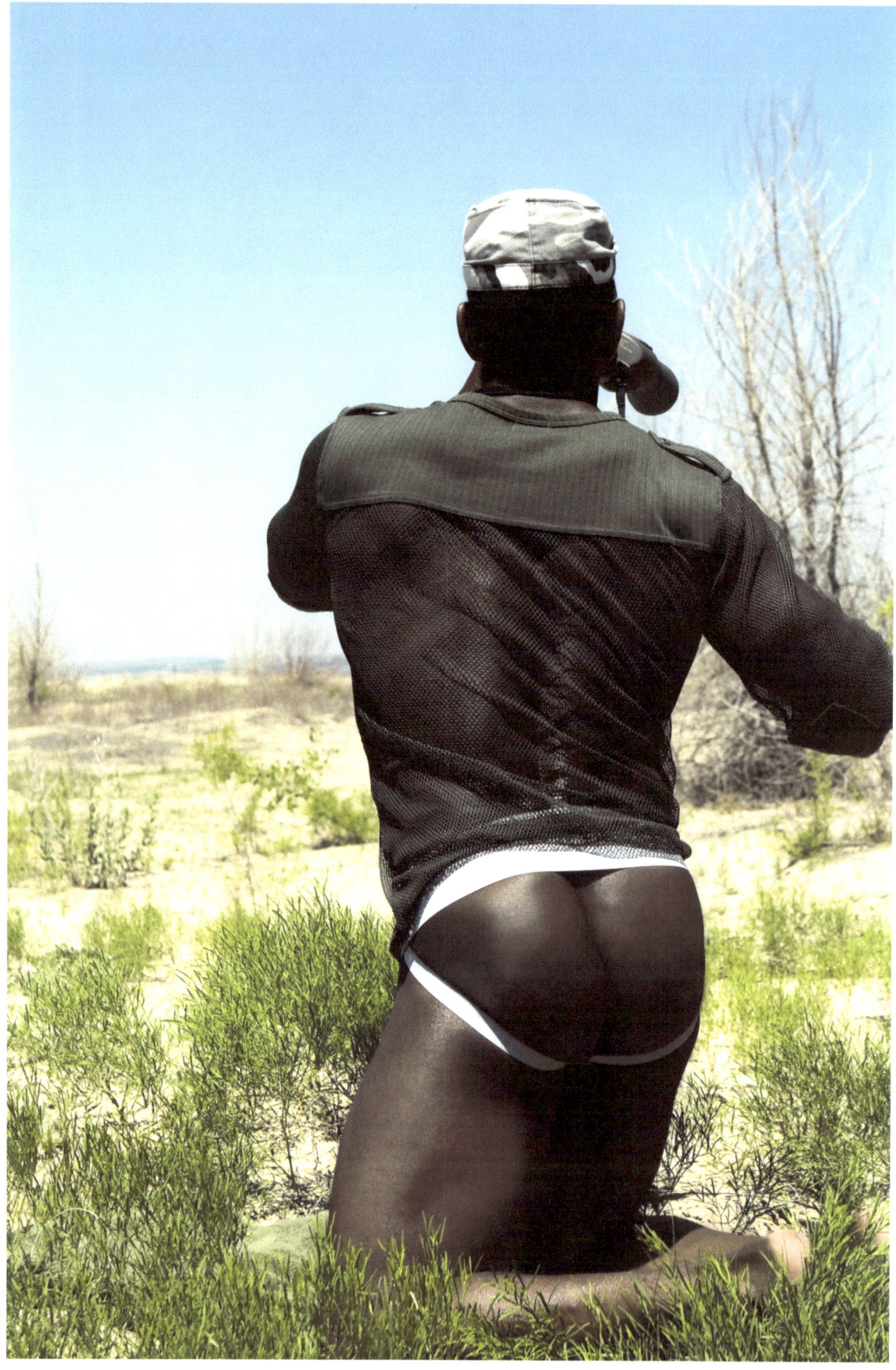

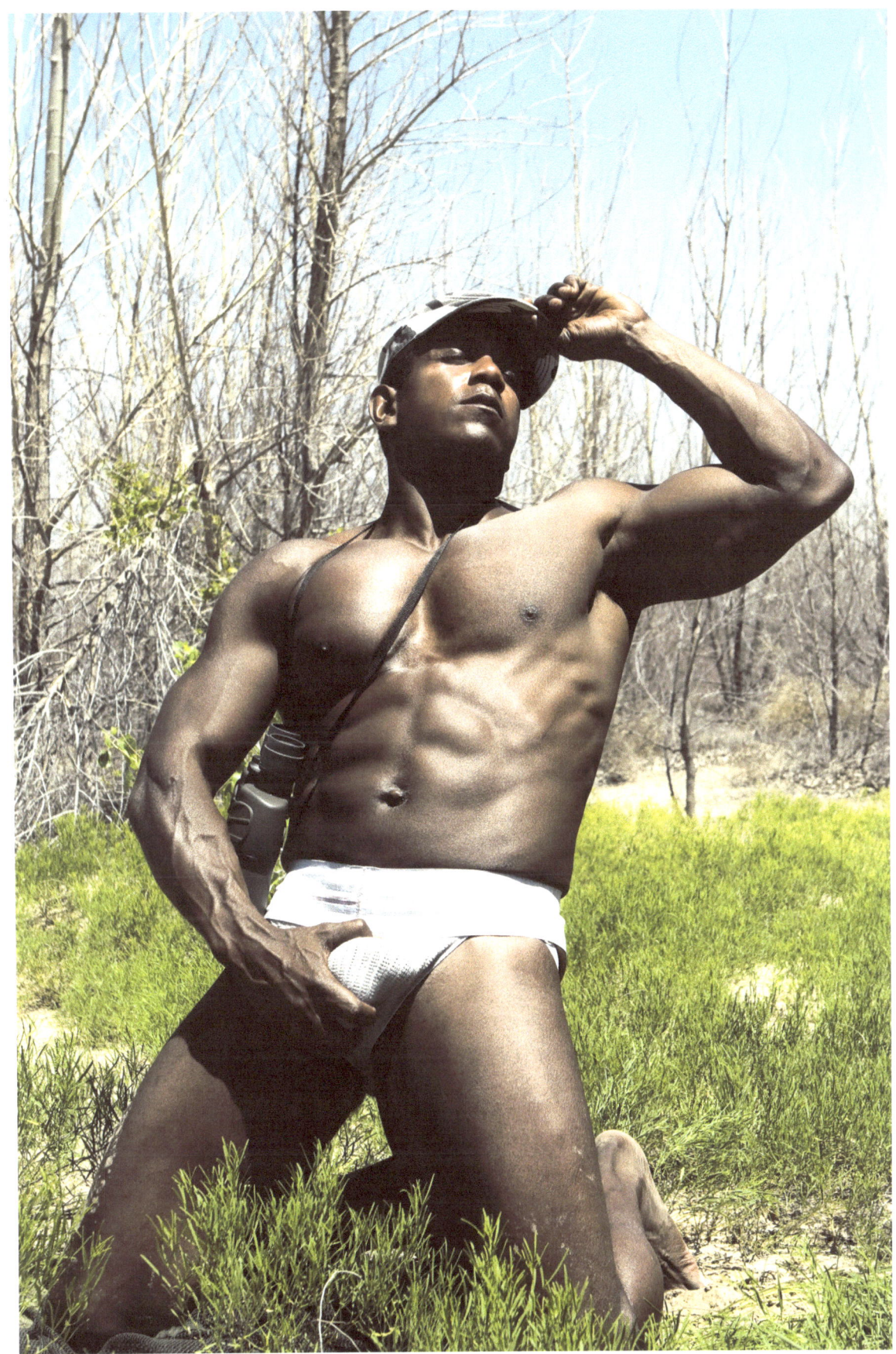

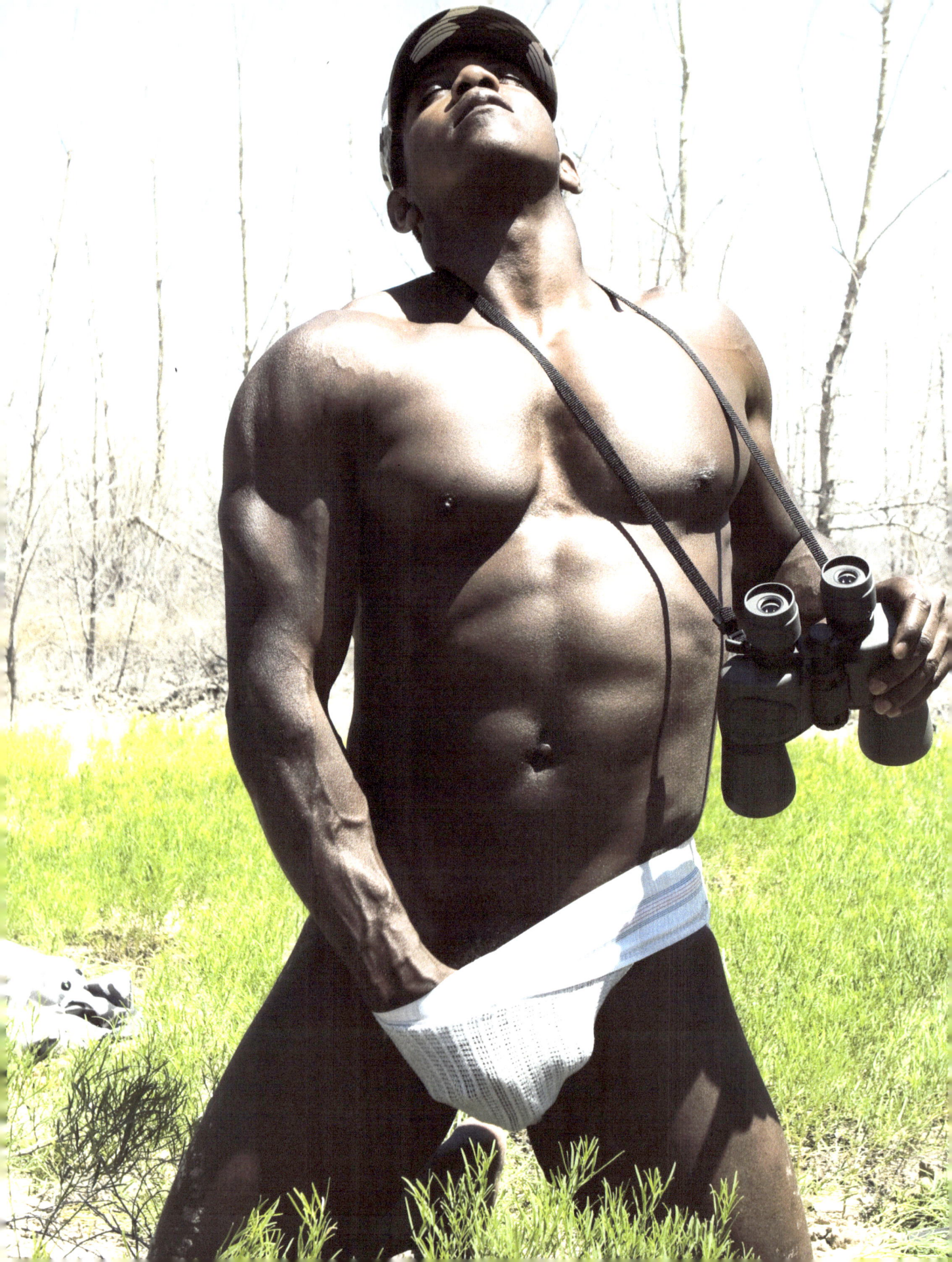

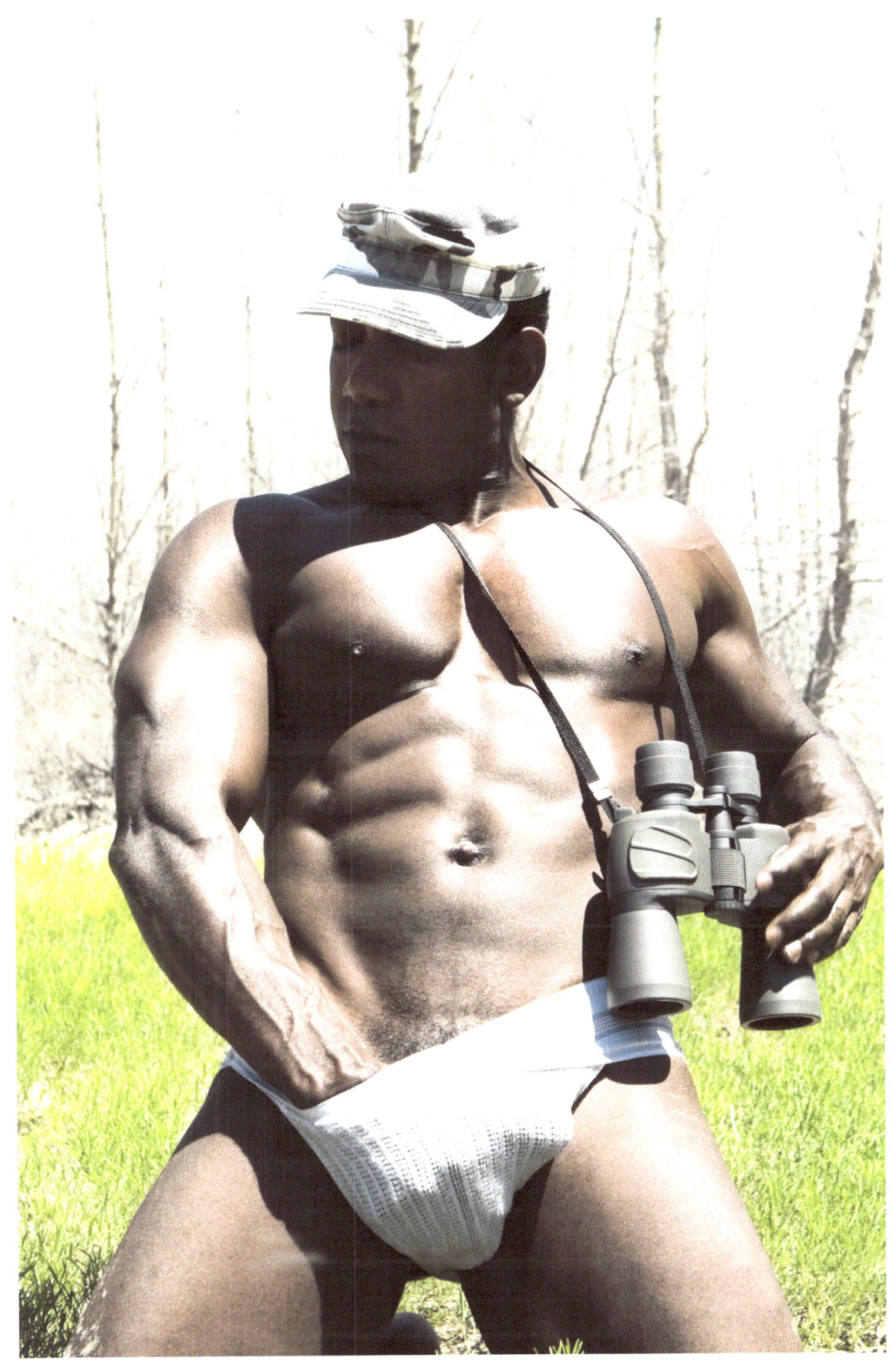

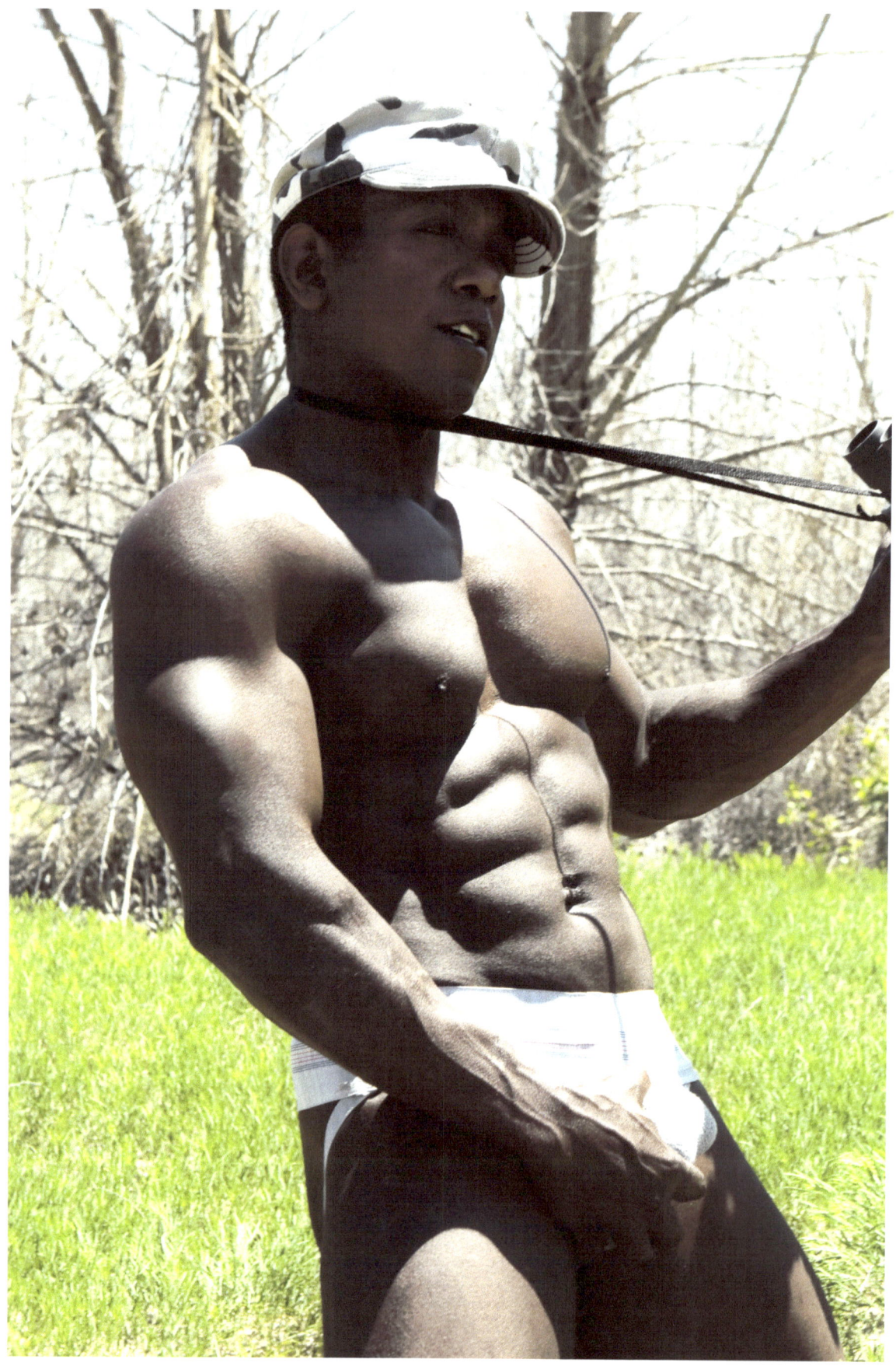

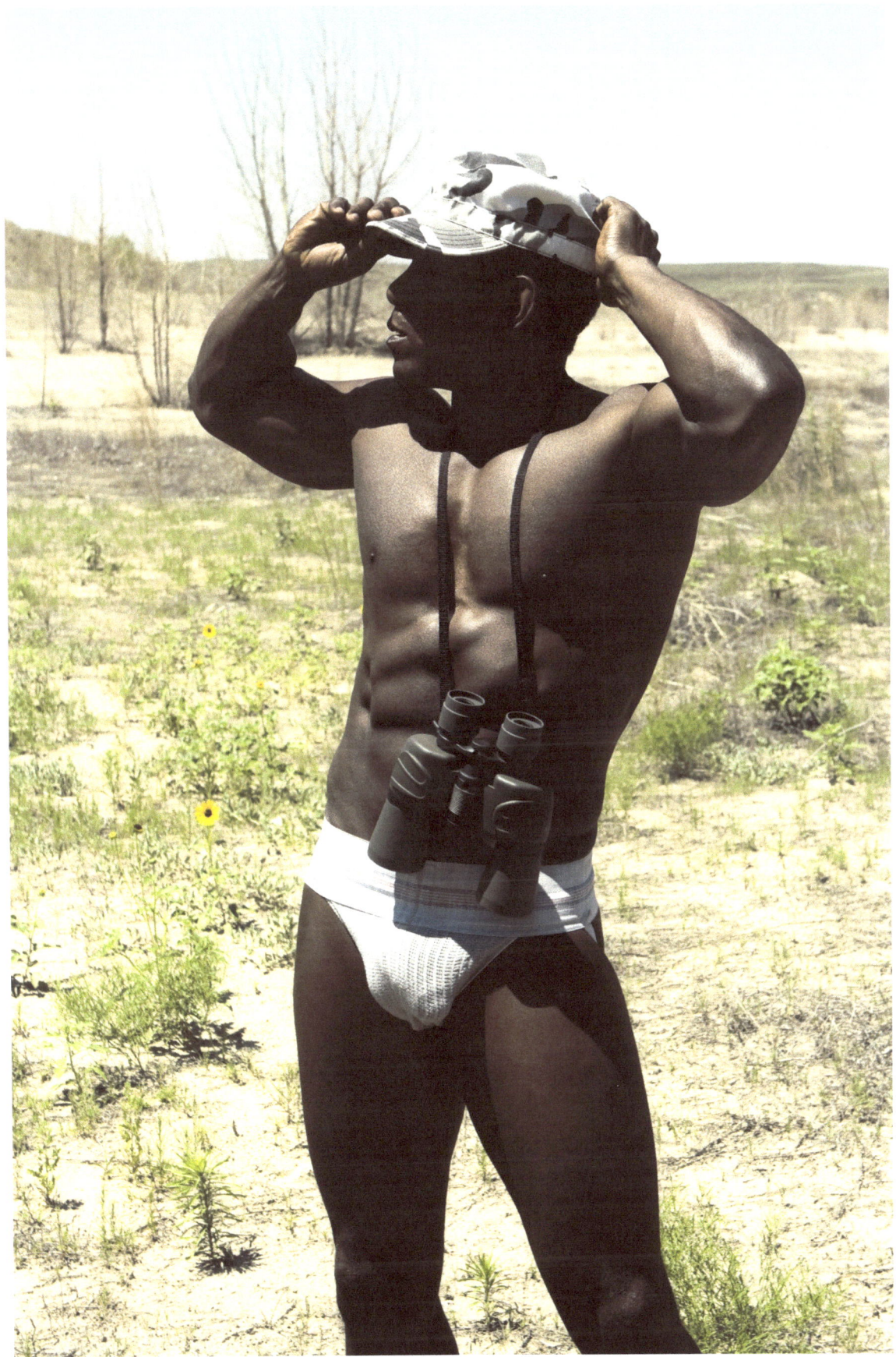

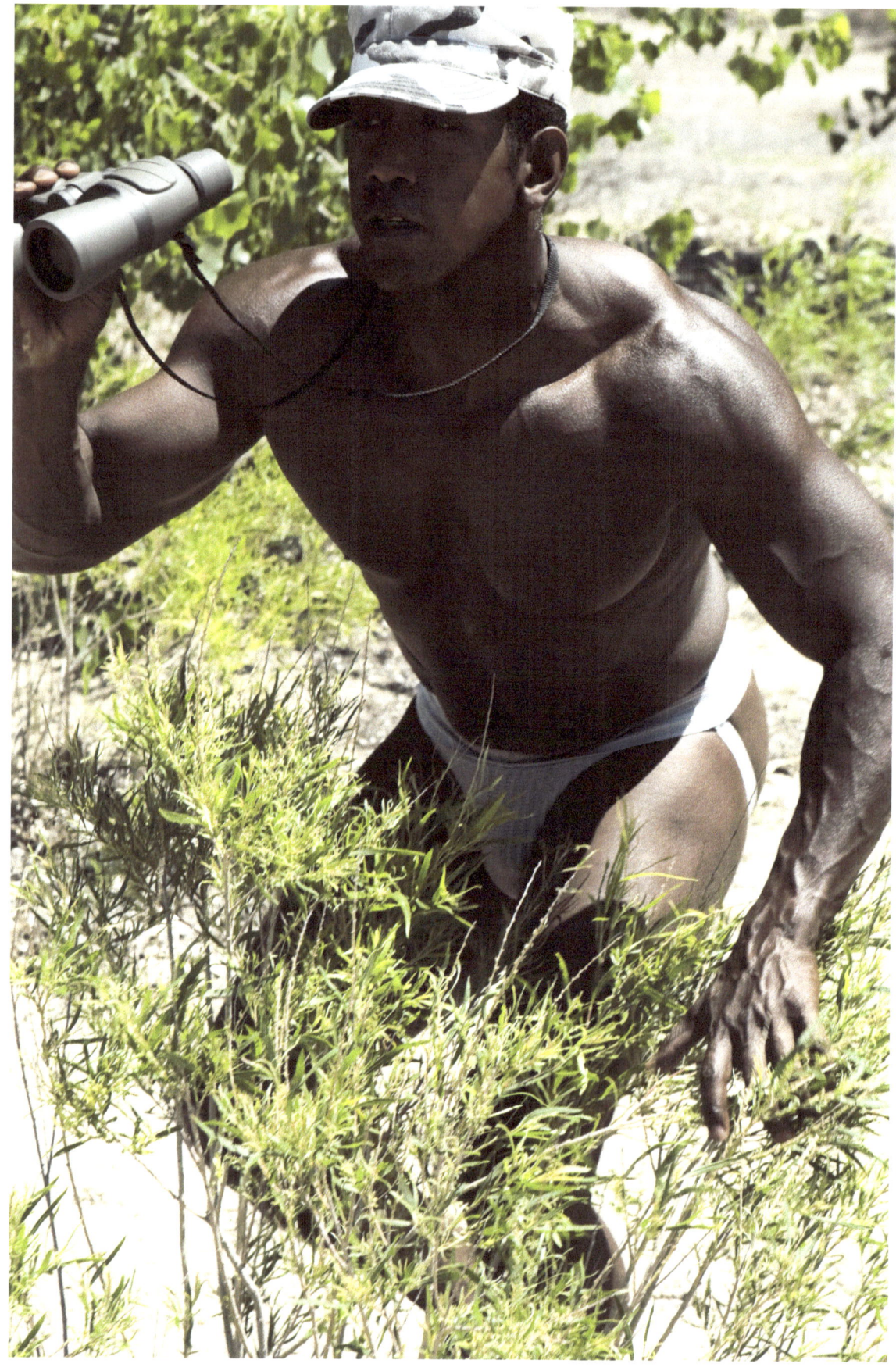

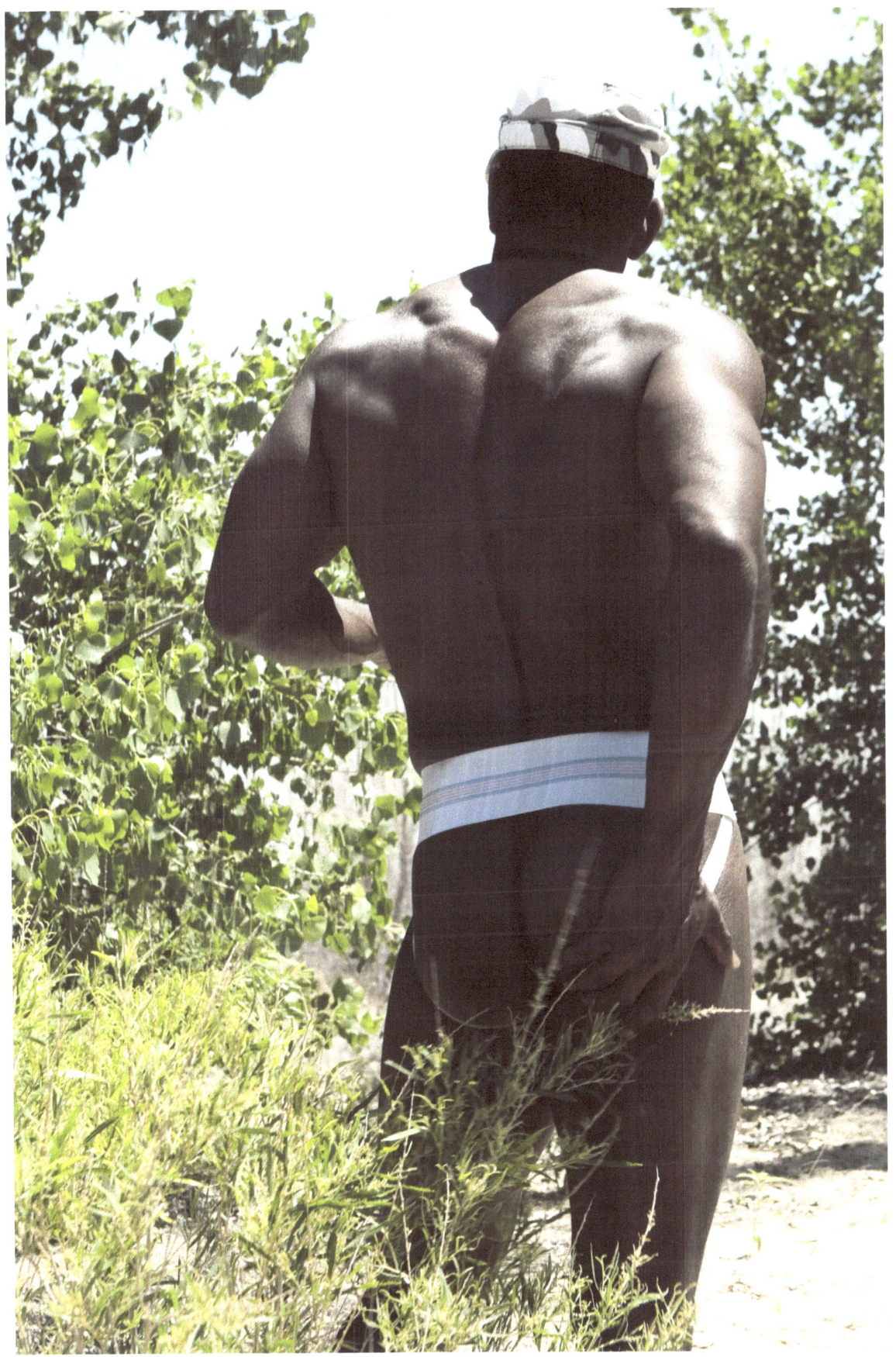

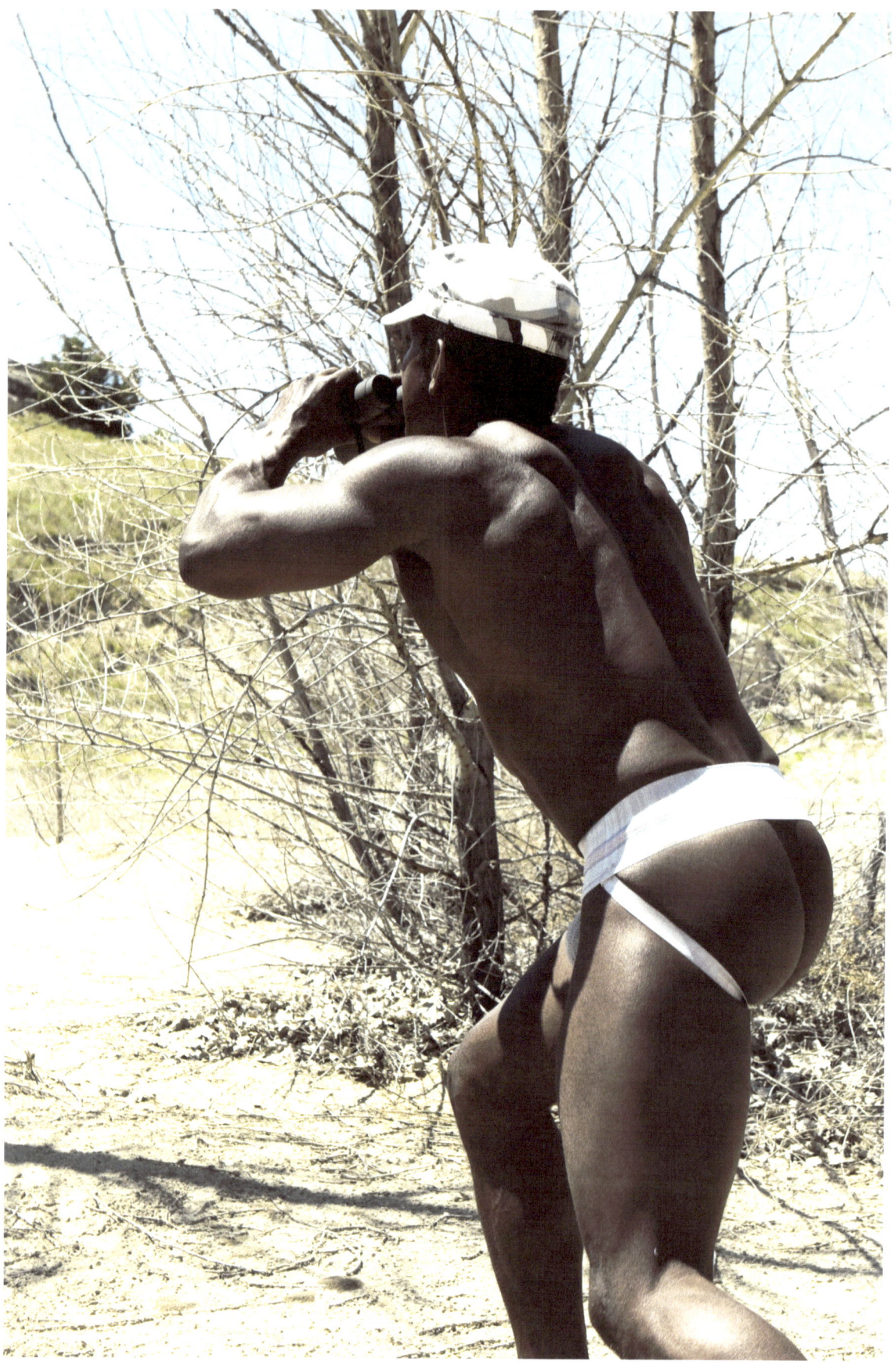

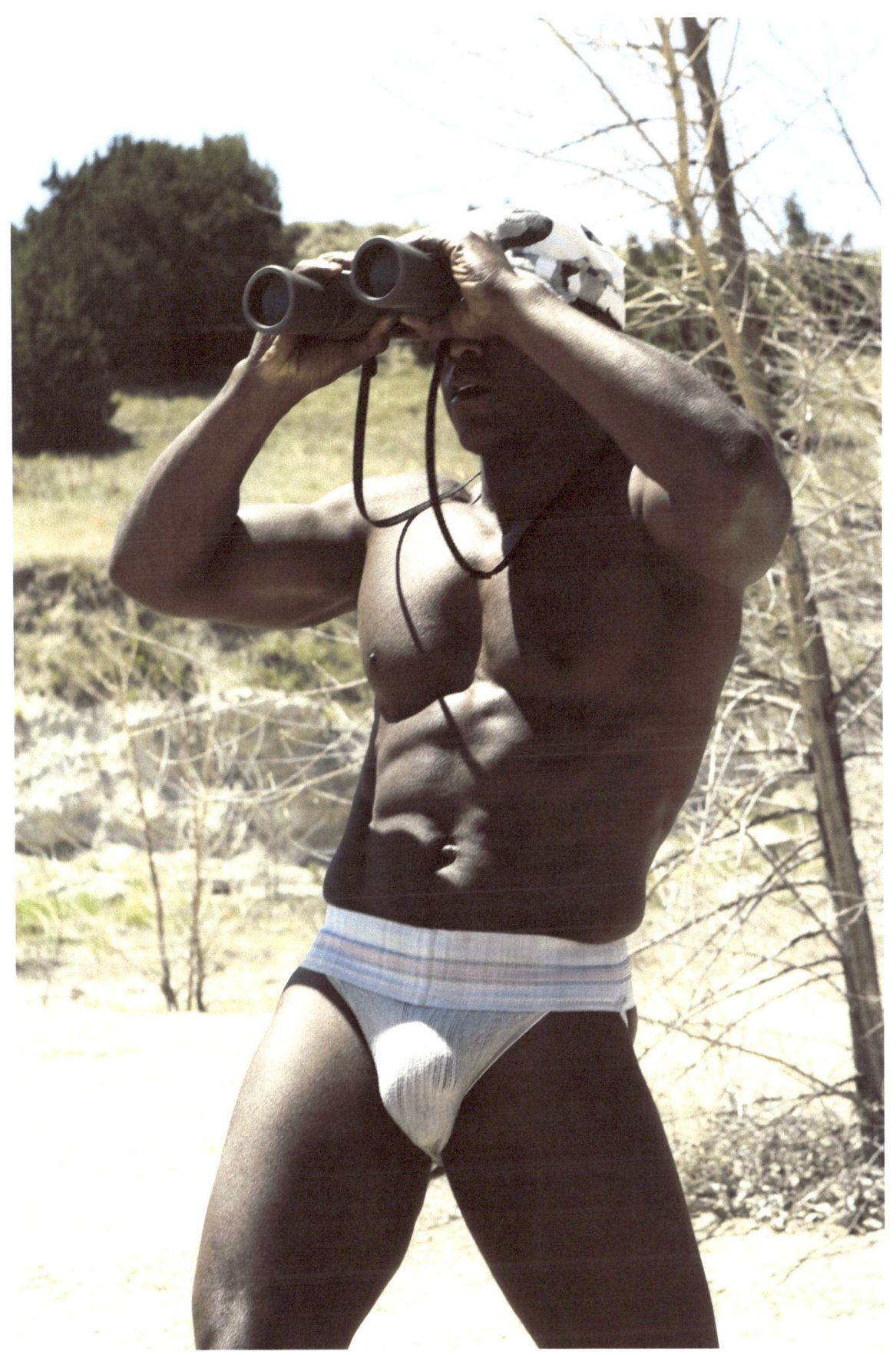

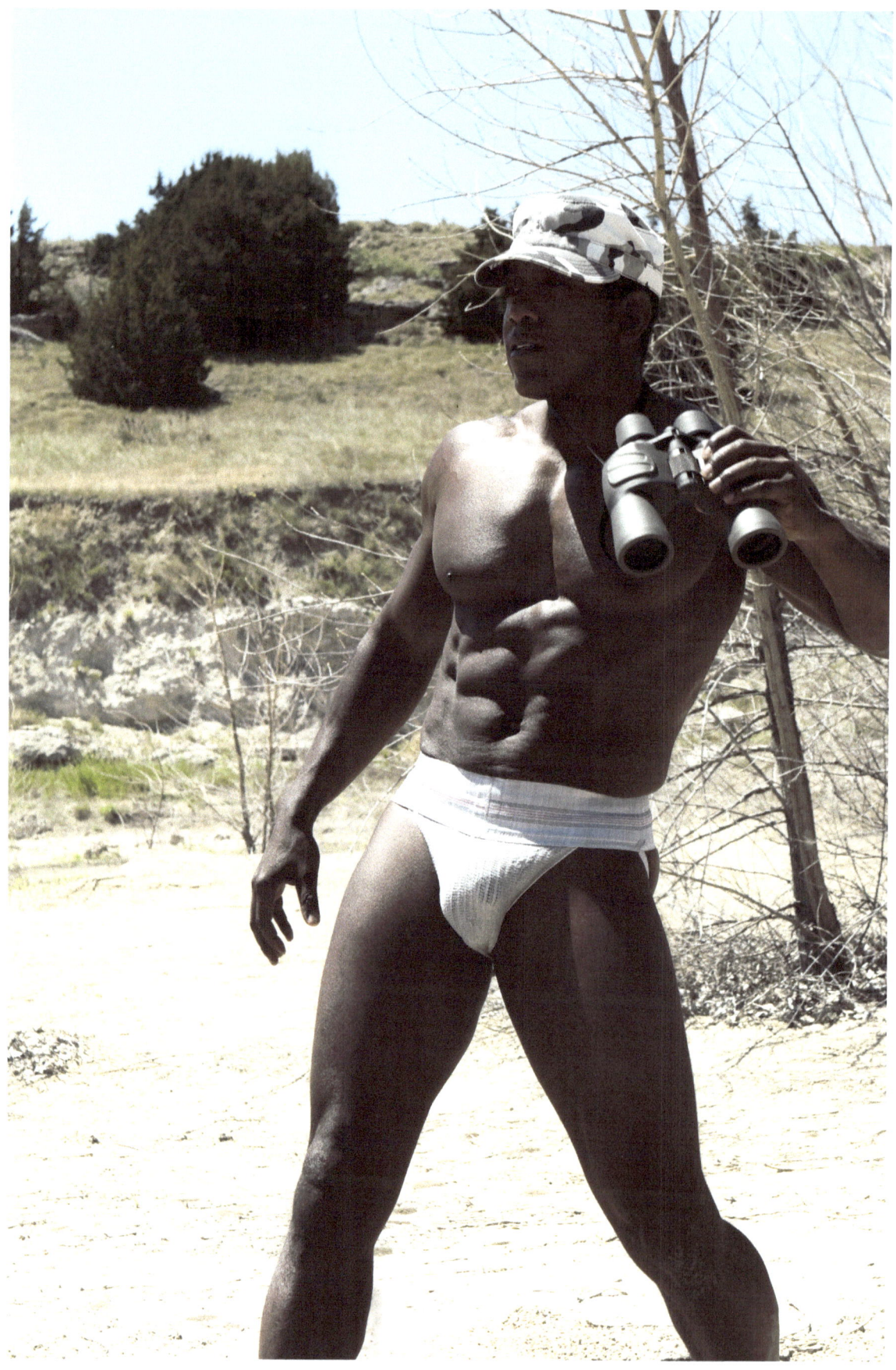

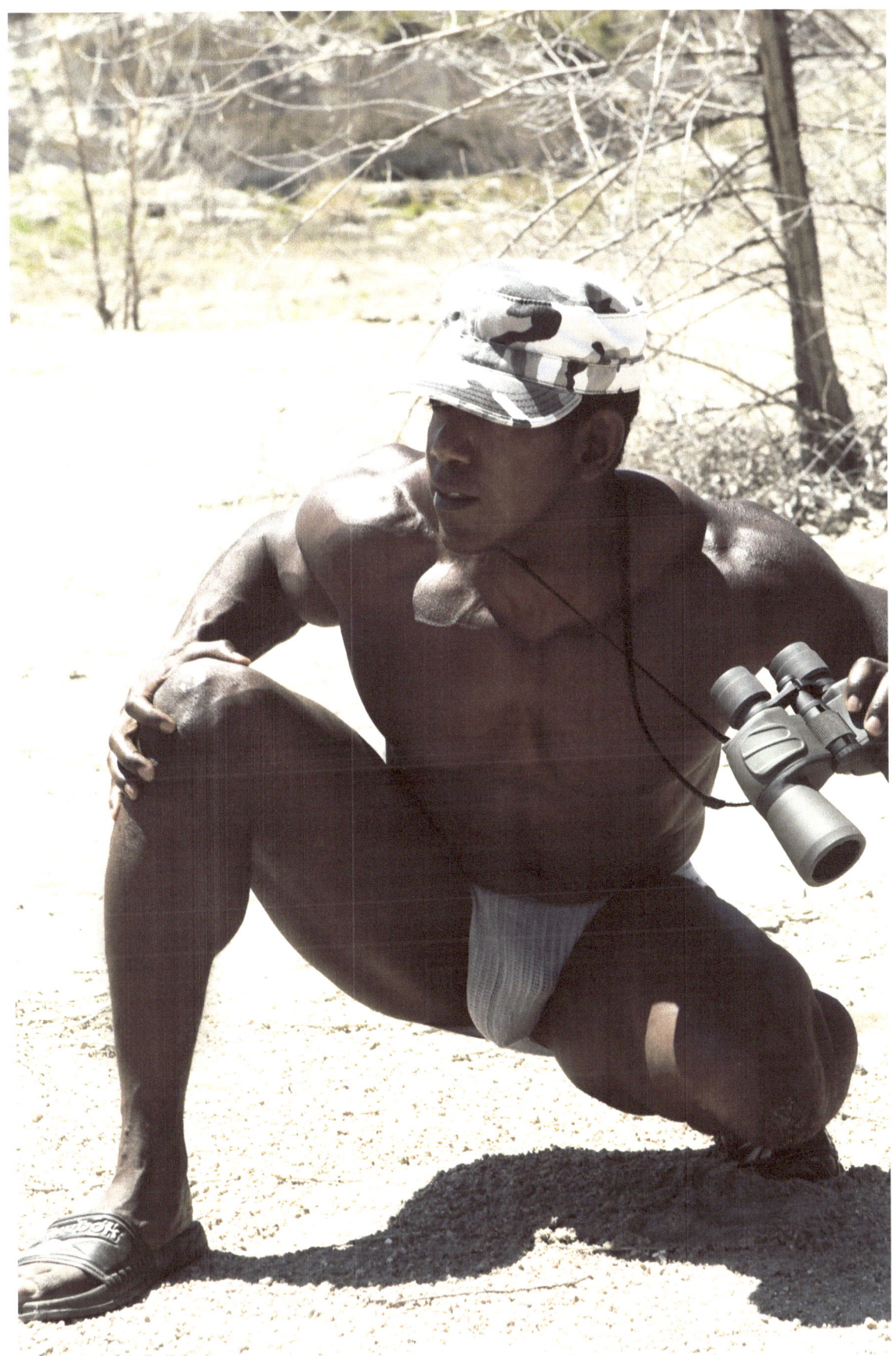

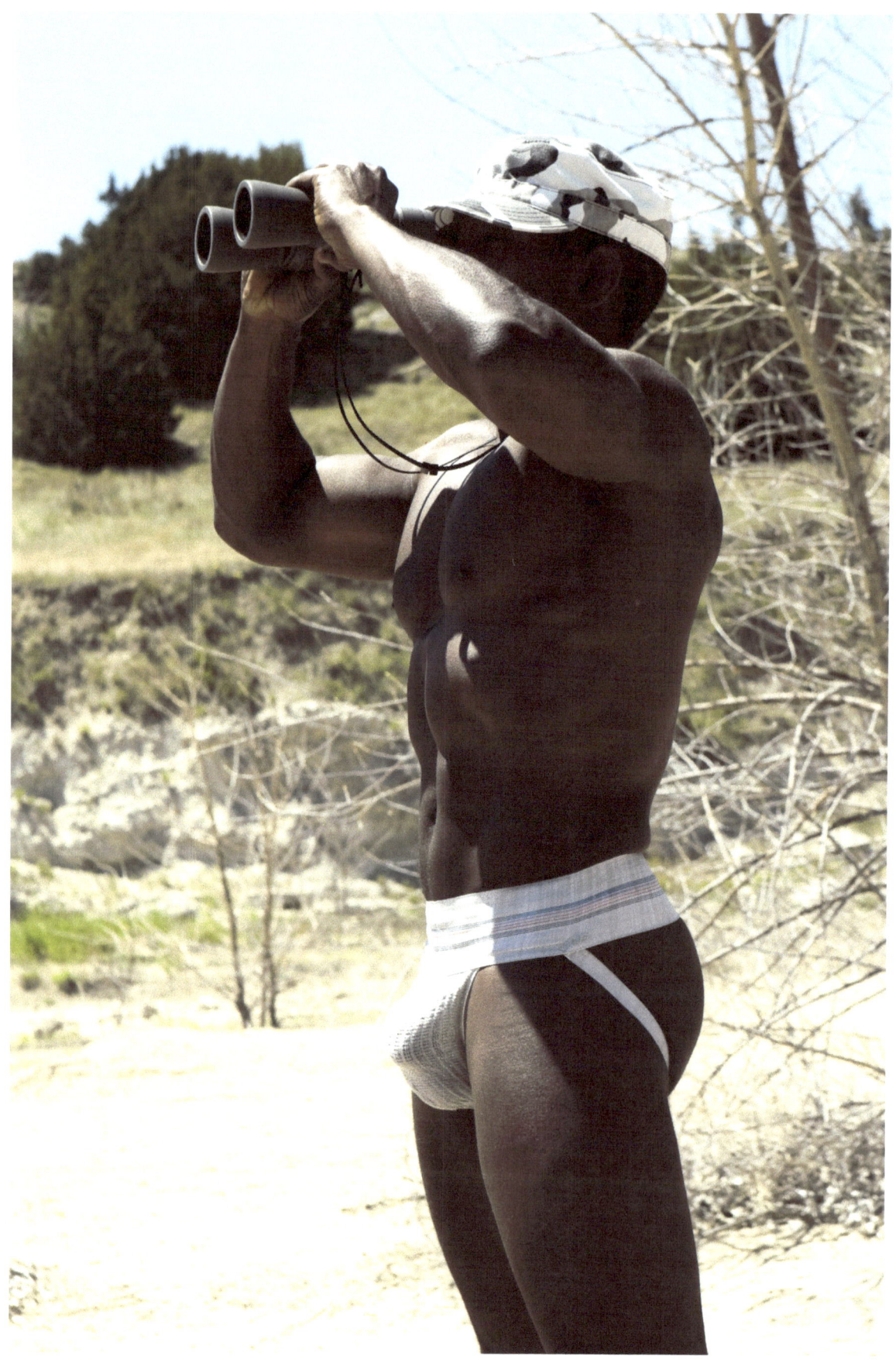

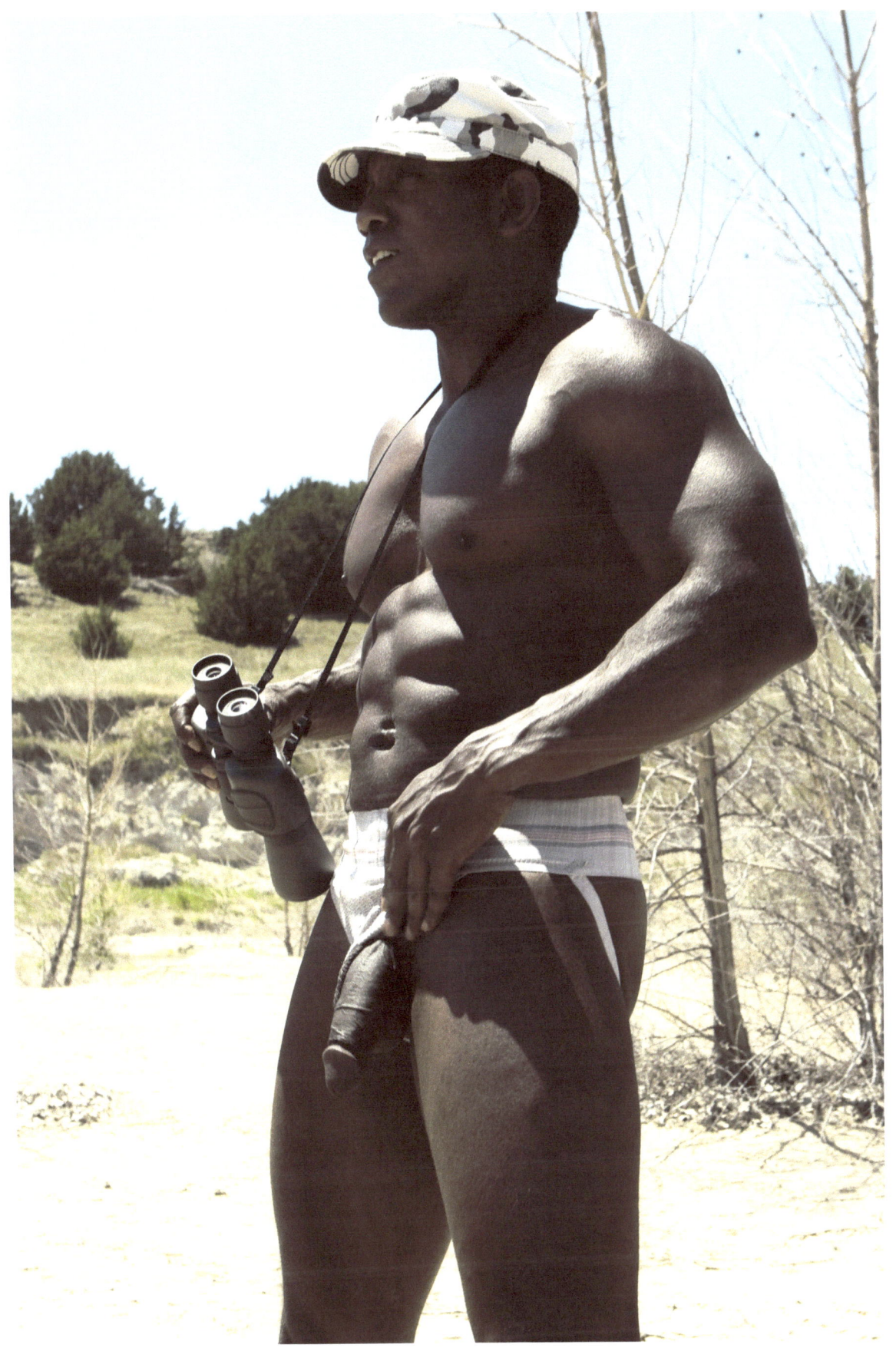

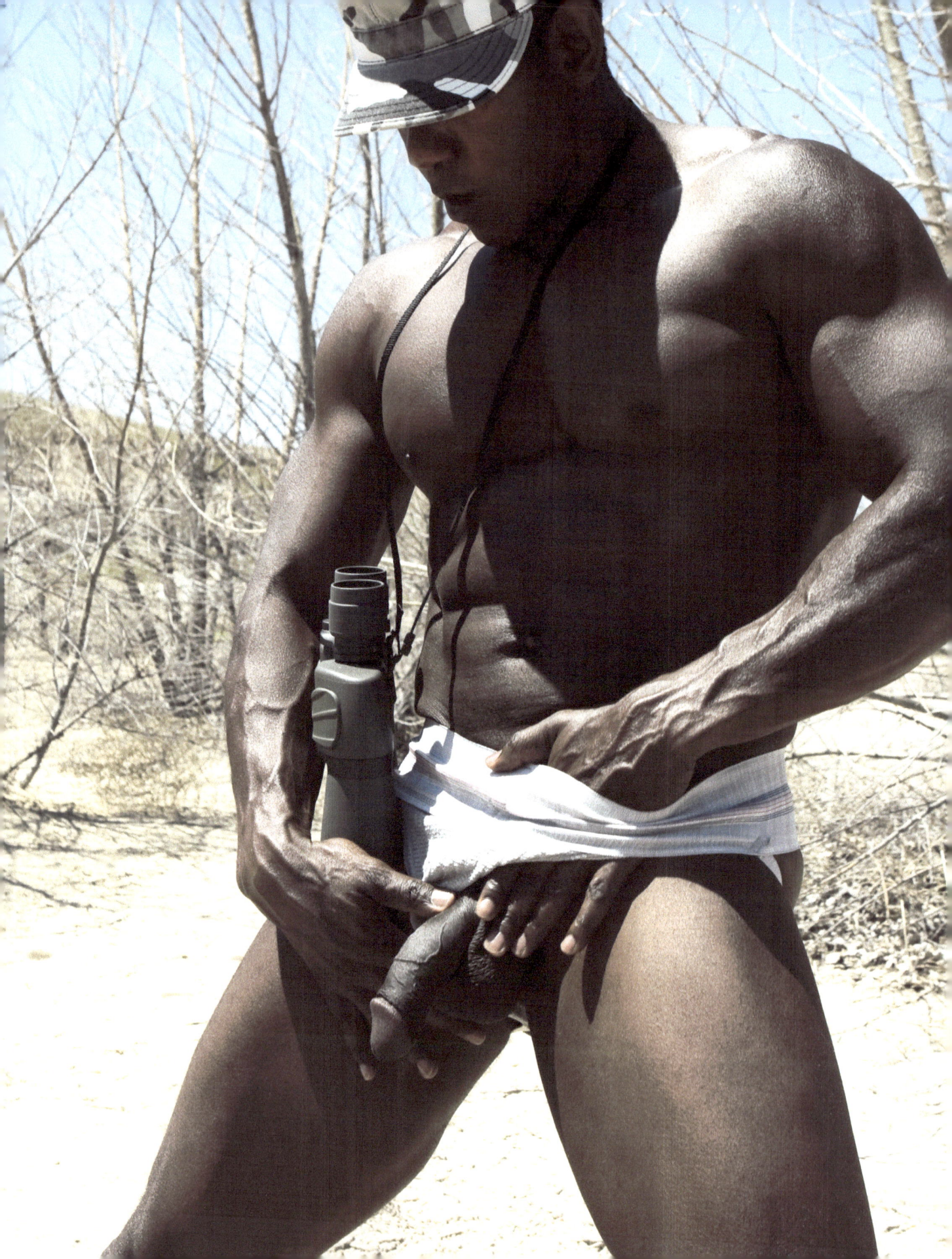

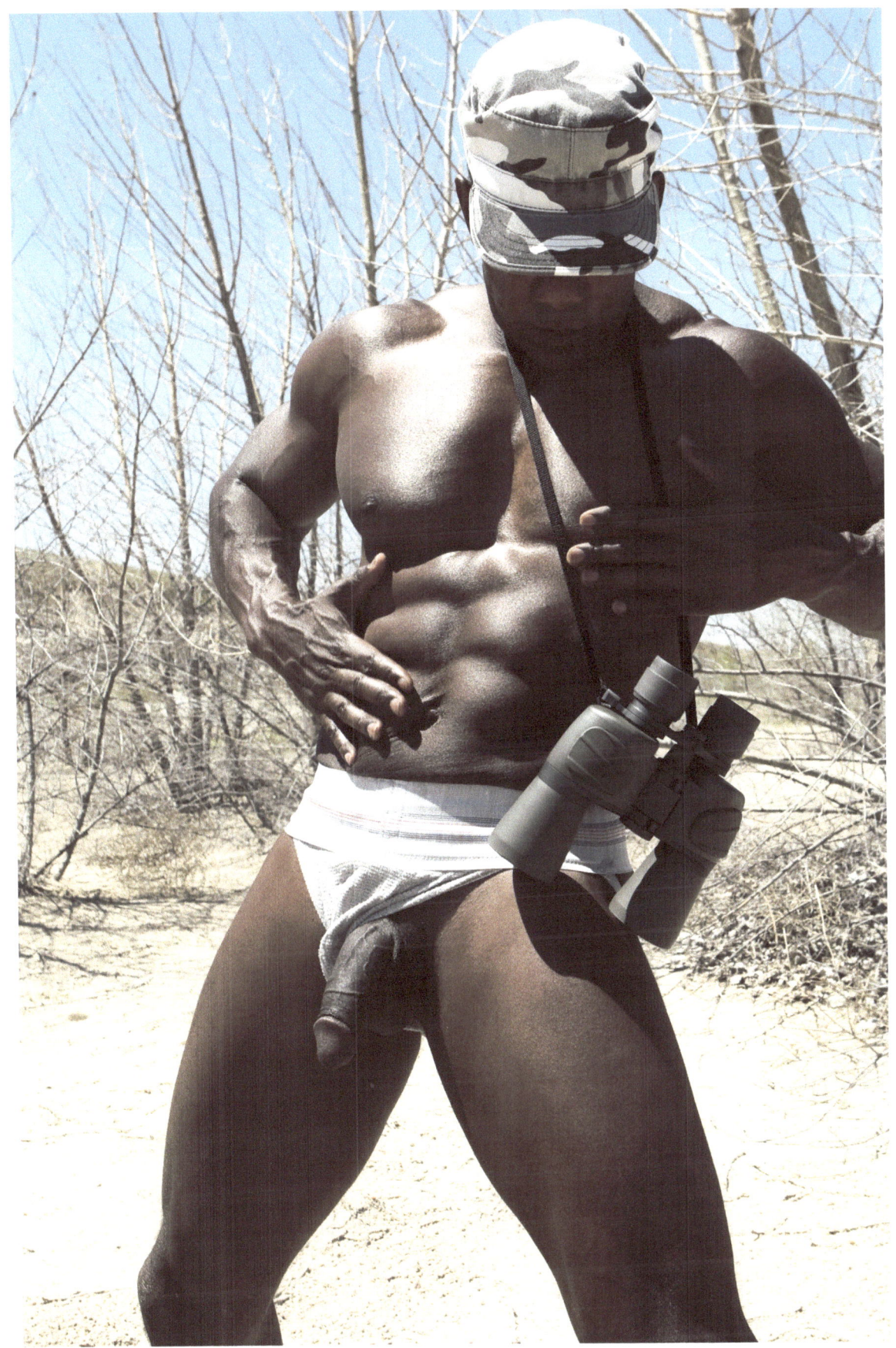

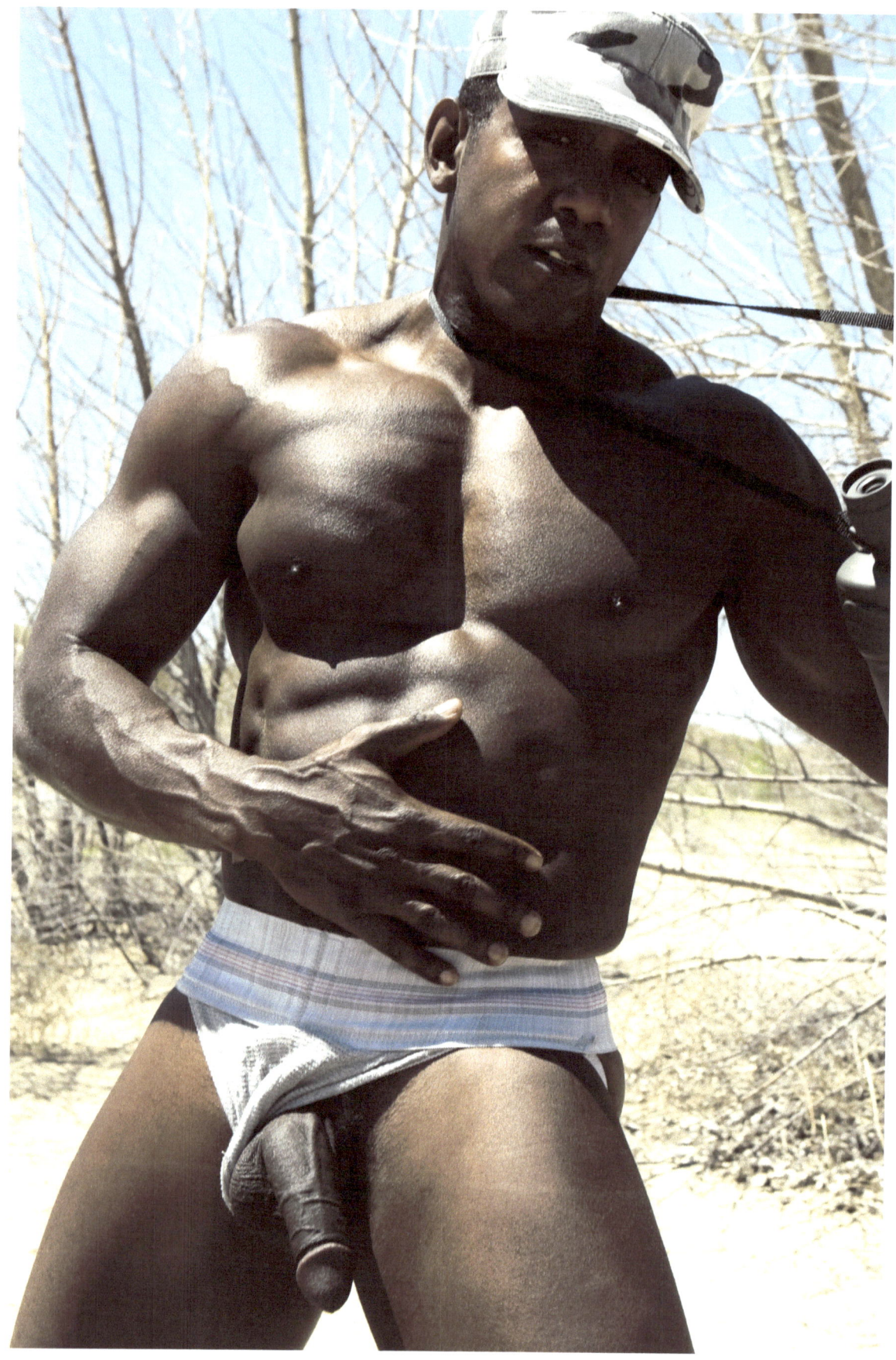

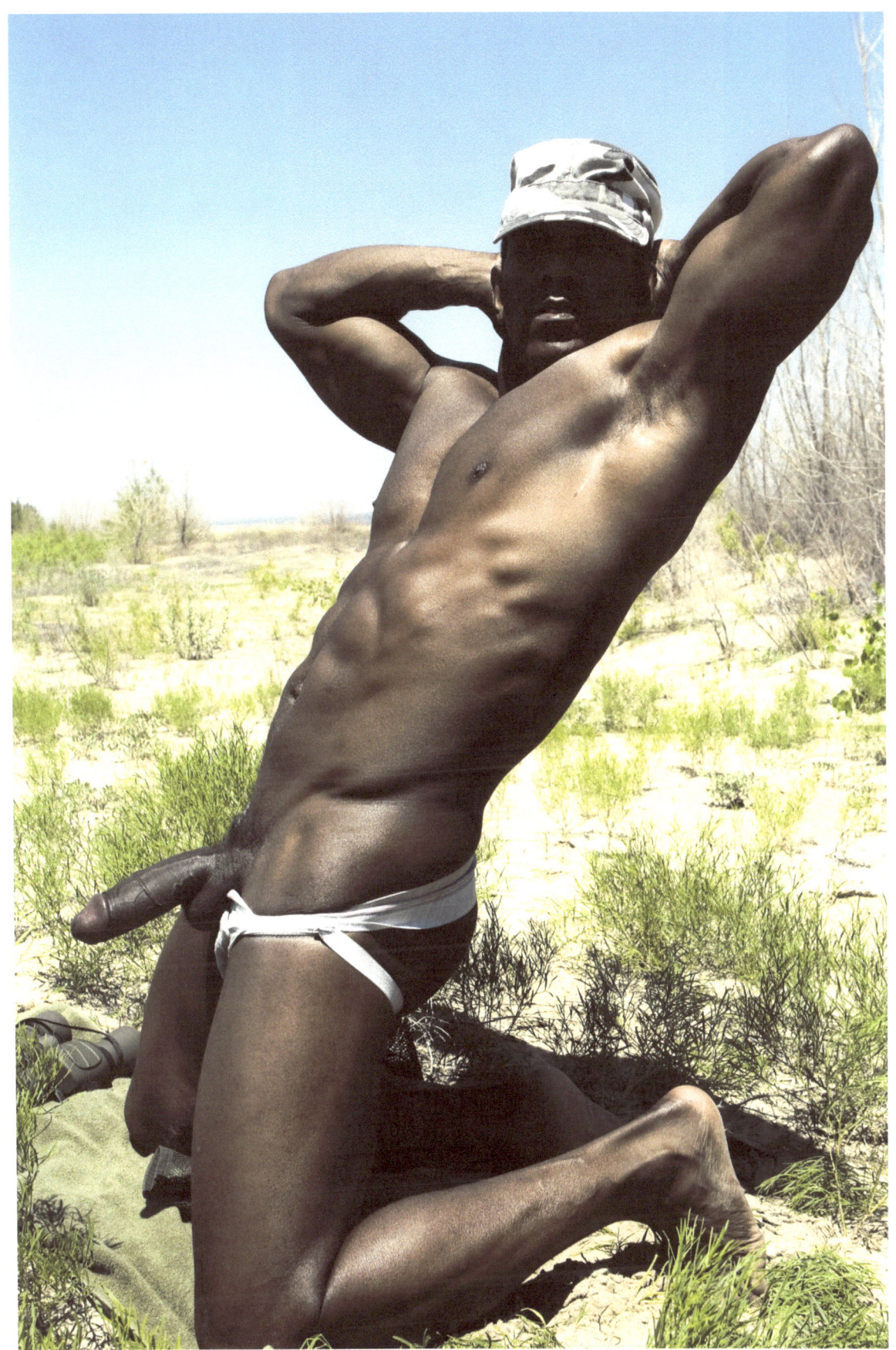

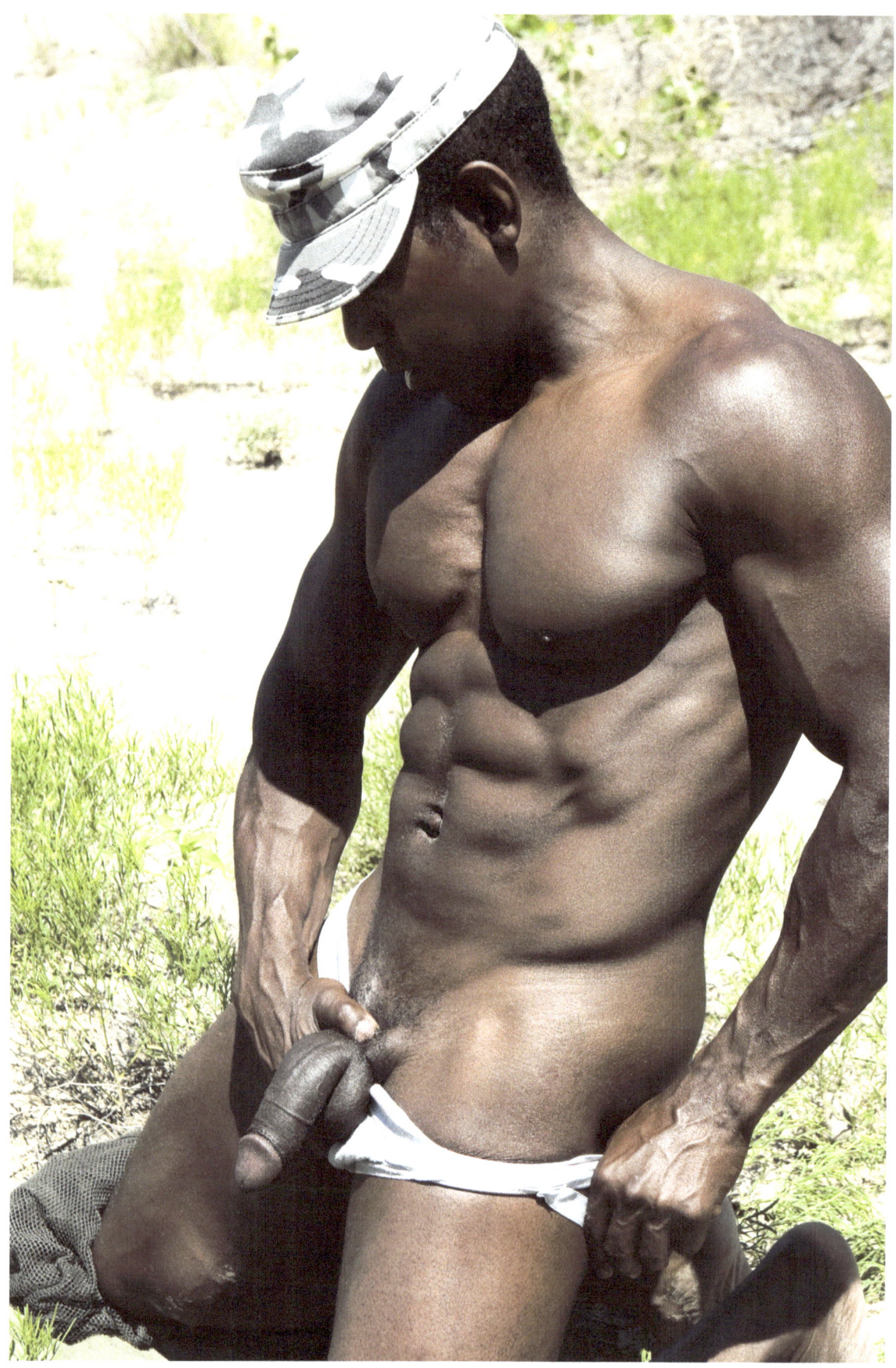

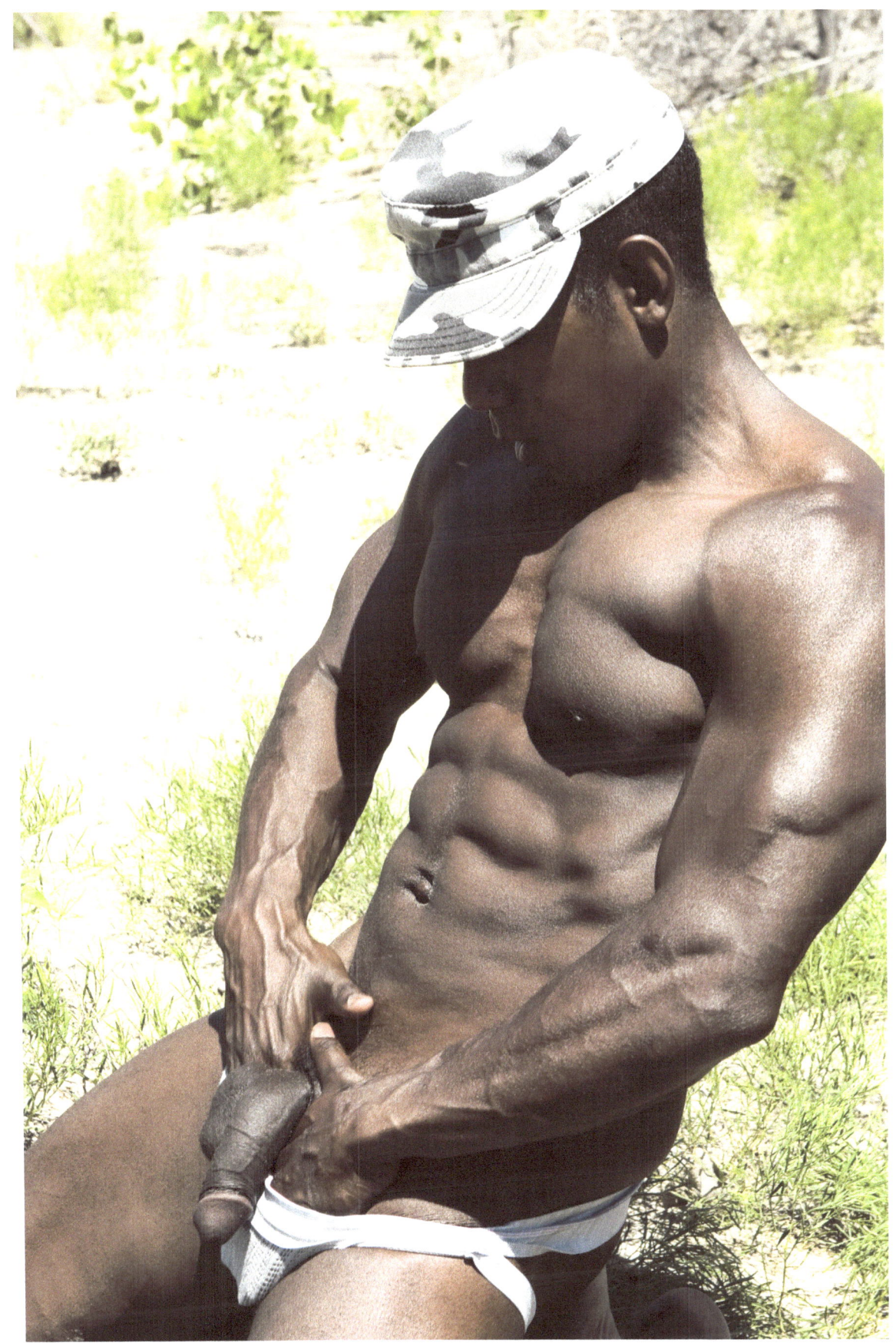

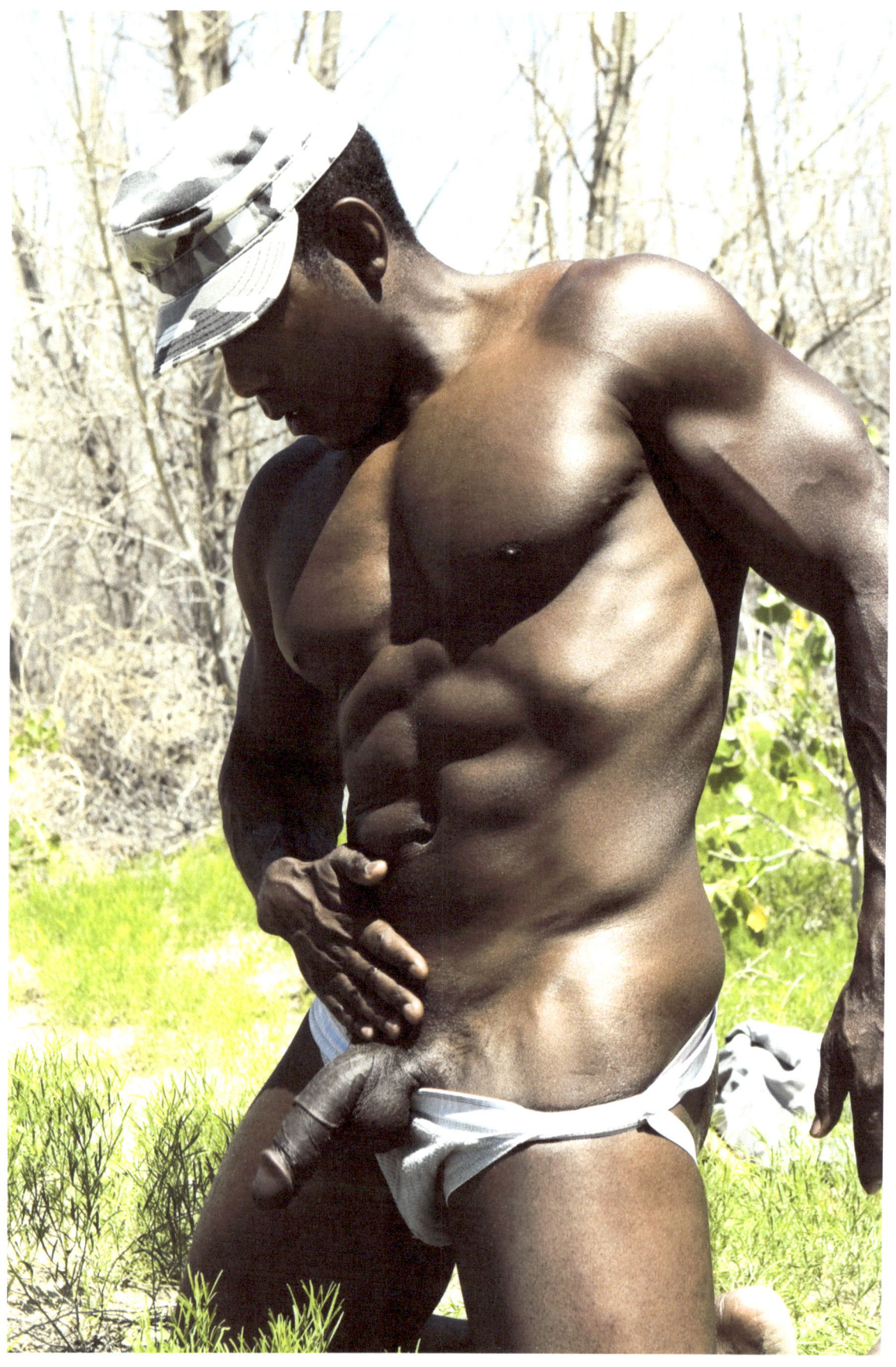

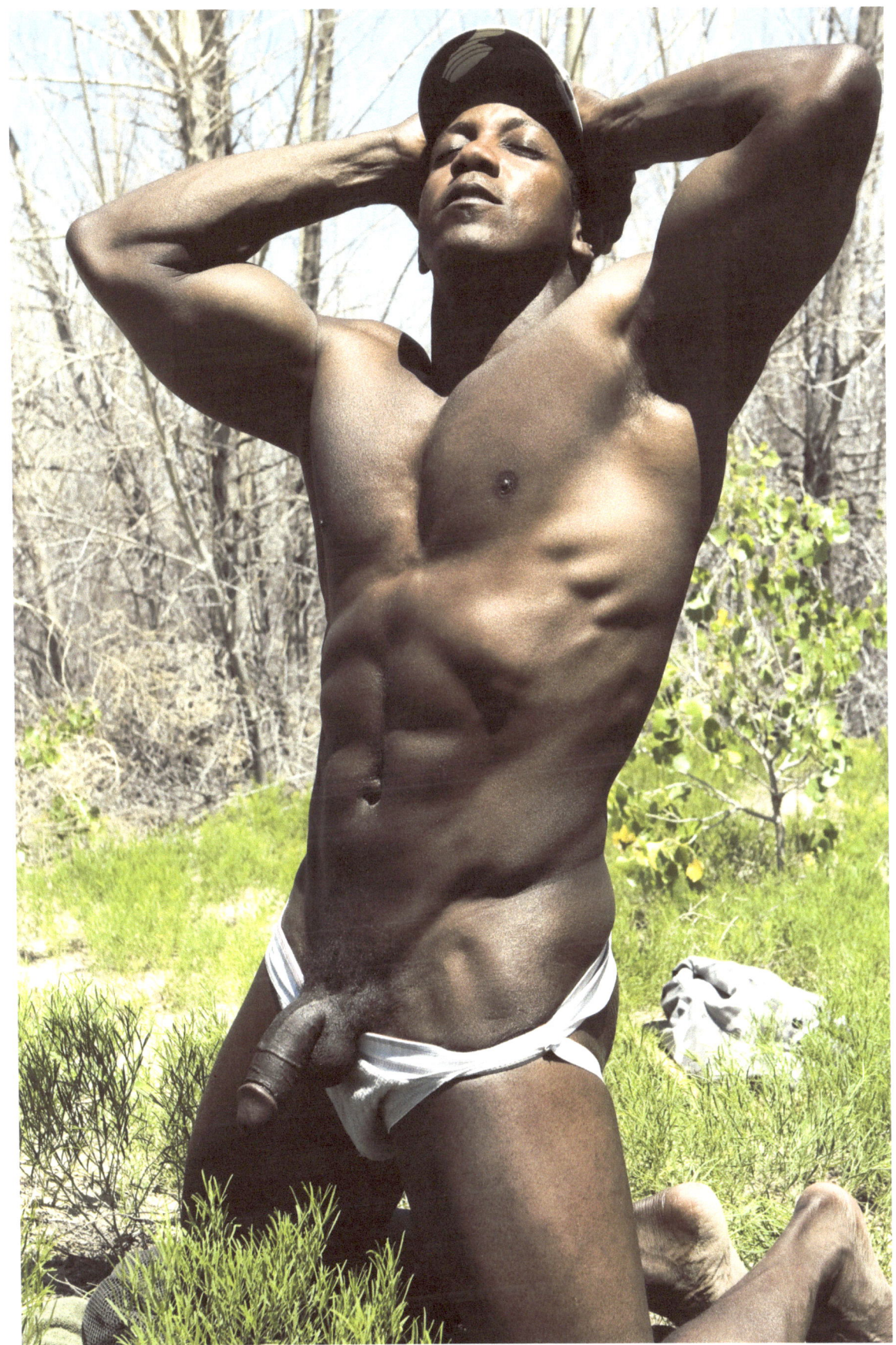

Now available on Amazon.com
COWBOY FANTASY
A Picture Book

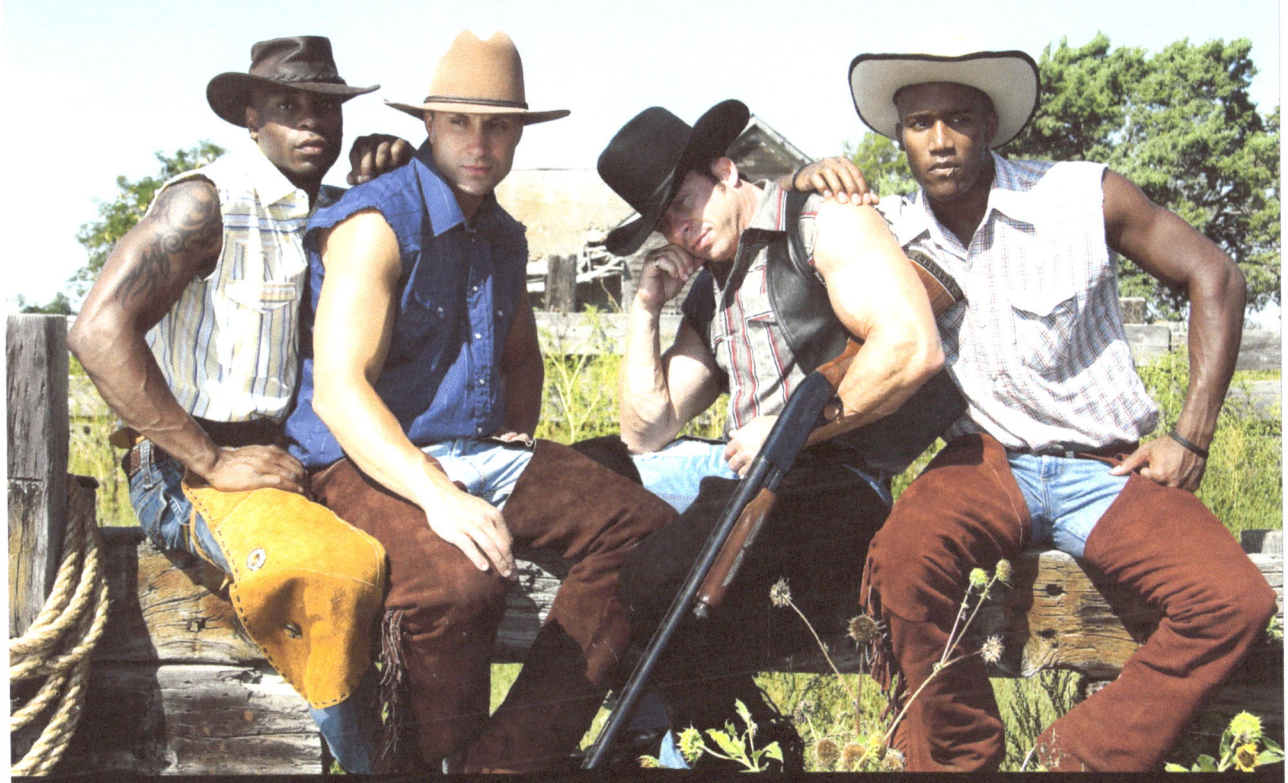

Color and black & white semi-nude and nude male physique photography by Prairie Visons Photography, Lincoln, Nebraska

Photographed in the Sandhills of Western Nebraska

INFORMATION

Learn more about Prairie Visions Photography at:

http://www.modelmayhem.com/pvphoto

or contact us via email:

FotoLNK@aol.com

www.ingramcontent.com/pod-product-compliance
Lightning Source LLC
Chambersburg PA
CBHW051050180526
45172CB00002B/581